Gunter Richter/Peter K. Burian
Nikon N70/F70

D1115883

Magic Lantern Guides

# Nikon
## N70 F70

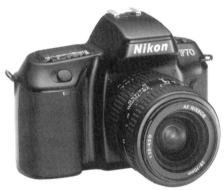

Gunter Richter/Peter K. Burian

**Magic Lantern Guide to**
**Nikon N70/F70**

A Laterna magica® book

Third Printing 1998
Published in the United States of America by

**Silver Pixel Press**
Division of
The Saunders Group
21 Jet View Drive
Rochester, NY 14624

From the German edition F70 by Gunter Richter
Edited by Peter K. Burian
Translated by Hayley Ohlig

Printed in Germany by Kösel GmbH, Kempten

**ISBN 1-883403-19-7**

# Table of Contents

# Foreword

The third camera to incorporate Nikon's latest generation of technology is the N70, designated as the F70 outside the U.S.A. Although bearing little resemblance to its more traditional predecessors, this is definitely a Nikon in terms of reliability and versatility. Its sculpted flowing lines combine functionality, elegance and superior ergonomics.

Although the N8008s/F-801s was a popular model, it belongs to a previous generation of autofocus and metering technology. In the upscale class, the N90/F90 (predecessor to the N90s/F90X) had been available for two years, and the entry-level N50/F50 for eight months. Finally, at Photokina '94, Nikon unveiled the N70/F70, an ideal alternative for those wanting a mid-priced SLR (single lens reflex) camera with the ultimate in technology. In many respects, the new model is competitive with the N90/F90, one of Nikon's most successful SLRs ever.

It's smaller and lighter than the N90/F90, with entirely different controls for simpler operation. At first glance, this may appear to be an entry-level camera, with its colorful display panel and symbols denoting subject-specific modes. While all the modern conveniences are indeed included, full override is possible. The N70/F70 allows the photographer to grow and explore new venues while controlling the amount of support from the camera's auto systems.

Locking autofocus (AF) on the most suitable point, or selecting the right mode to depict the scene exactly as pre-visualized, requires user involvement. This calls for an intentional step as well as an understanding of the results each setting will produce. You can use the N70/F70 as a totally automatic camera, however its high-tech exterior hides a fully manual model ready to respond to your specific demands.

While the instruction manual is better than most in explaining which buttons to push, it cannot help you to achieve beautiful pictures by exercising photographic skills. This guide will demonstrate how to get the most out of your N70/F70 in combination with the essential concepts of photography. Only by relating the

camera to real-world situations can the individual functions be explained. After all, photography is far more than knowing which controls to activate and in which sequence.

In this guide, we'll mention each of the buttons and dials but will emphasize what these devices can help to achieve. If you want more shooting advice, other Magic Lantern Guides provide detailed information about Nikon system accessories. These are the *Magic Lantern Guide to Nikon Lenses* by B. "Moose" Peterson and the *Magic Lantern Guide to SB-25/SB-26* by Huber and Peterson. We wish you lots of fun and plenty of extraordinary photo opportunities as you begin to explore the possibilities offered by this versatile Nikon camera.

**Significant Technical Advances**

The technical advances built into the N70/F70 are impressive, with exposure metering and autofocus comparable to that of the upscale N90/F90. These include 3D Advanced Matrix Metering (with Distance Data Detection) for superior exposure accuracy, wide area/cross field autofocus (AF) sensor for reliability, and advanced software for lightning-fast Tracking Focus when subjects are in motion. These, plus the most advanced flash metering system, make the N70/F70 a strong contender in a highly competitive price class. With its pop-up Speedlight, extremely logical LCD display panel, three quick recall functions, and hushed film transport, this model should convince many people to invest in this autofocus SLR.

The small, built-in Speedlight is highly sophisticated and controllable, with functions usually reserved for external, accessory flash units. This is the first Nikon camera with built-in flash exposure compensation and bracketing, highly useful for overriding the system when desired.

More importantly, perhaps, the N70/F70 offers a high level of compatibility with the powerful SB-26 Speedlight, as we will see. This camera's 3D Mult-Sensor Balanced Fill Flash system is nearly identical to that of the N90/F90 which has already become a backup camera to the F4 among many professional photographers. Its advantages can be accessed fully with the lift-up Speedlight or the SB-24, SB-25, and SB-26 accessory units.

The Spot and Center-Weighted pattern or the eight-segment 3D Matrix system allow for precise metering or automatic exposures

of high accuracy. There is also a full selection of exposure modes: from Auto-Multi Program (with user shift) through Aperture- and Shutter-Priority to manual and eight Vari-Programs optimized for specific subjects and situations. Automatic exposure bracketing, an analog display scale to guide careful manual control, exposure compensation and shutter speed control in 1/3 EV steps will be appreciated by anyone serious about photography.

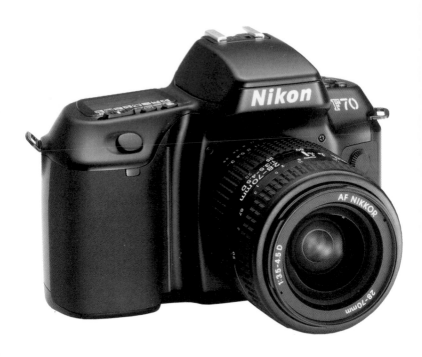

# A New Operating Concept

In our opinion, a prerequisite to straight-forward camera operation is logic. In other words, controls must be logically placed, logically designed, and clearly marked. And the N70/F70 follows a very logical operating sequence, allowing all functions to be accessed quickly. Become familiar with the basics of operation and the meaning of the symbols, and you're off and shooting.

All of this is simplified with a new control concept for greater convenience. Control buttons are color-coded and correspond to the displays on the large, sectional fan-shaped LCD display. There are few buttons, and the entire process becomes logical and simple once you appreciate this new concept.

The N70/F70 also boasts modest size and weight. This was made possible, at least in part, by two 3 volt (CR123A) lithium cells instead of a larger single 6V model or multiple AA batteries. New to Nikon is the hushed operation: the N70/F70 is surprisingly quiet in the single and 2 frame per second (fps) film advance. Silent rewind can be selected to further reduce any clatter.

## Logical and Intuitive Controls

While the multitude of functions made possible by micro computers offer staggering flexibility, they do have one potential disadvantage. If every single function required a dedicated key, operation would become so complex that the camera would be unusable. On the other hand, if a single control must be used for a dozen functions, the process can get confusing. Photographers would either be referring constantly to the operating instructions or scrolling through numerous menus in search of a needed function.

All manufacturers have become more and more concerned with finding new operating concepts that are easy to understand and to remember - intuitive, in other words. As a result, quick operation becomes possible with little need to refer back to the instructions. Nikon took a substantial step in this direction with the N70/F70,

using a menu system, a few buttons and a single dial. It is called the Command Input Control System.

**Ease of Selection**

Practically the entire right "shoulder" of the camera is covered by a larger-than-average, color-coded LCD (liquid crystal display) panel. At first glance, the multitude of information on display may look confusing. Fortunately, that's an "optical illusion". Just as the menu in a French restaurant looks confusing to someone who is not bilingual, it becomes crystal clear once he gains the necessary language skills. With the N70/F70, various symbols and abbreviations must first be understood. But don't worry, it is far simpler than learning another language.

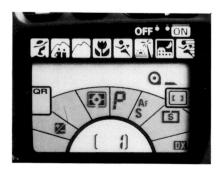

The symbols and data displayed on the large LCD panel of the camera may seem confusing at first, but this panel soon becomes the key to super-fast operation.

So pick up the camera, press the Function key and rotate the Command Input Control dial, watching the pointer as it stops at each symbol. "Ah....that must be Flash Exposure Compensation", you'll say when noting the [+/-] symbol next to a lightning bolt, and so on. You may not recognize all of the symbols instantly, especially if you have not previously owned a multi-mode Nikon SLR. However, once you are aware of all the N70/F70's functions, each symbols' meaning is fairly self-evident.

The three primary controls are the Function key and the SET key on the left plus the previously mentioned Control dial that protrudes slightly over the camera back below the LCD. Press and hold the Function key down and turn the dial; a small black pointer skips from one section of the LCD panel to the next. This allows you to select desired functions quickly and easily.

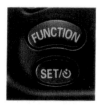 

Pressing the Function key takes the LCD panel into function mode. Pressing the SET key then accesses the individual functions. Both keys work in conjunction with the Control dial on the right rear of the camera.

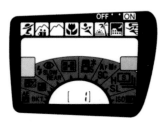

You will never see all of this data displayed at one time. For the sake of simplicity, only those which apply to the settings in use are visible.

The Function key has fulfilled its purpose for now. Let's check out the SET key as it controls easy navigation within the functions. To make a setting, simply hold the SET key and turn the Control dial. Note the small clock symbol on the SET key: if it is pressed for several seconds, it activates the self-timer. More specific, step-by-step guidance on how to access every function is appropriately described throughout this Guide.

**Customized Programs**

Above the LCD panel, is a row of pictograms or icons denoting the subject-specific Vari-Programs; Portrait, Landscape, Sports, etc. Press the "Ps" key at the top left, and a small, black arrow appears under the row of icons. If you turn the Command Input Control dial while holding the "Ps" key, the arrow moves from left to right. Stop at the runner icon, for example, and the camera is set for Sports Program, to be described later.

As you can see, everything works particularly quickly and is elementary. Because the controls are so logical, it's difficult to make a major error or become totally confused once you have mastered the operating sequence. Granted, this will take time if you have just moved up from a conventional SLR camera. You will want to work through this Magic Lantern Guide with N70/F70 in hand to become fully proficient with the numerous functions. Take this one step at a time, practicing what you learn in each chapter in actual photography.

## Other N70/F70 Controls

Let's take a glance at a few additional controls and features. Some should be familiar if you have used other cameras. On the left side of the camera, note the two buttons marked IN and OUT; these return the camera to factory-programmed settings. Later, you'll use them to store favorite settings for quick recall. That will be useful for specific subjects: sports, landscapes, portraits, etc. when the factory-programmed Vari-Programs do not satisfy your creative intentions.

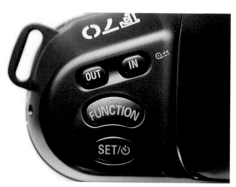

The OUT and IN keys control the storage and subsequent recall of three groups of customized settings. Quick recall of factory-programmed default settings is also possible.

The IN key has a second function: it activates film rewind when the "Ps" key is depressed at the same time. This is why both sport a film cassette symbol, as a reminder of how to activate rewind.

On the right side of the camera next to the "Ps" button is a button with an [o] symbol on it. This controls the AF metering area; both Wide-Area and Spot autofocus are available. Further to the

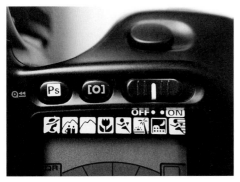

Pictured above the Vari-Program pictograms (from right to left) are the Main Power switch, the AF field control and the Flexible Program button. In conjunction with the IN button, the Ps button also activates film rewind.

right you'll find the main power switch with only two options: ON and OFF, without extra choices (on other cameras) which can complicate the process.

The shutter release button or trigger is ideally located. Your index finger naturally rests in this area. It works in two steps: a light touch activates the metering and autofocus systems as well as all of the symbols in the LCD panel and viewfinder. Press it down completely and the shutter opens, making the exposure.

Try the two steps without loading film until you get the "feel" of the process, to avoid accidentally making an exposure with excessive pressure on the trigger. The N70/F70 helps you out with a clearly defined contact point that reduces the risk of an unintentional exposure.

Nikon designed the built-in Speedlight to be higher above the lens axis than most. This helps reduce red-eye while allowing the use of many lenses without blocking t he light.

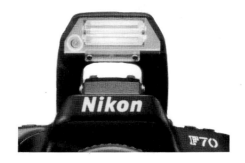

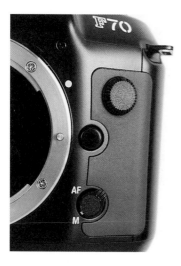

Top right: the remote control terminal, covered with a screw cap; the lens release button is in the center; the autofocus/manual focus selector is at the bottom.

On the front of the camera, under the trigger, you'll find a small red lamp, the LED (light emitting diode) that blinks when the self-timer is in progress. The viewfinder prism has a hot shoe (for accessory flash units) with several contact points used for communication of data with an external Speedlight.

This leaves the right, front side of the camera. On the side of the prism, the flash release button allows the built-in Speedlight to be raised. There is also a remote control terminal (covered with a cap) for an electronic cable release. In the middle, directly beside the lens mount, you'll find the lens release button and the autofocus/manual focus switch.

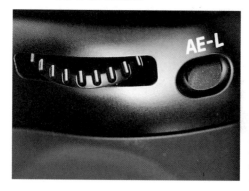

The AE-L lever, located beside the Control dial, is used to lock in autoexposure settings while recomposing.

The control dial protrudes conveniently on the back of the camera. On its right is the AE-L key (autoexposure-lock) for holding exposure settings in automatic modes while you recompose. The back release is on the left side of the camera. The tripod mount and battery compartment lid located on the camera bottom are self-explanatory.

## The Viewfinder

We use the term single lens reflex (SLR) often. This simply means you view the scene through the same lens that forms the image on the film rather than through a second viewing lens or through a viewfinder not connected to the camera's optical system. As a result, accurate framing and composition are possible no matter what lens is mounted and regardless of subject distance. The new Clear View screen of the N70/F70 is particularly bright, for ease of composition and focus even in low light.

The image seen on the screen represents approximately 92% of the image area, 8% less than will be recorded on the film. Why does it not show 100%? First, the cost of making a prism/viewfinder with full coverage would increase the weight, size and price. (The pro F4 is one of few cameras which does provide 100% coverage). Secondly, the final print or slide will not show 100% of the image area anyway. Not all of the negative is reproduced in prints, and a slide mount does mask some of the picture area. So the missing 8% not only keeps the cost down but also provides a

The viewfinder display is comprehensive, and includes (depending on the mode) an analog scale showing exposure deviation from the camera's metered value.

more accurate look at the image which will be provided by the film lab.

The N70/F70's autofocus system contains a high-density, cross-hatched sensor, meaning it is sensitive to both vertical and horizontal lines. This makes autofocus detection particularly fast and reliable, minimizing the frustrating "hunt and seek" which is common with older AF cameras. Two square brackets on the screen show the Wide-Area (7mm) focus detection sensor. The small circle within the brackets represents the narrow Spot focus detection sensor, useful for pinpoint control, for example focusing on an eye in a portrait.

This small circle also indicates the area which will be read by the camera's meter using the Spot metering mode. The larger circle represents the area which will be given primary emphasis by the exposure meter in Center-Weighted metering mode.

The exit pupil is located approximately 18mm behind the eye lens. In other words, you can hold the camera a full 18mm from your eye, which is appreciated by anyone who wears glasses and cannot hold his eye right up to the eyepiece. The entire screen and readouts can still be seen at a glance, increasing ease of use.

**The Viewfinder Display**
Nothing encroaches on the image area of the viewing screen but you can also see all-important data at a glance. A second LCD (liquid crystal display) panel is located under the screen with symbols which are brightly illuminated when the metering systems are in operation.

The information offered by the display is abundant: selected AF detection area size, "in focus" indicators, metering mode in use, exposure mode, program shift (if activated), selected shutter speed and aperture, electronic analog display to guide manual metering, and exposure compensation in use. When flash is recommended, the camera so indicates with a symbol right under the viewing screen. There is rarely a need to remove the N70/F70 from eye level except to change modes or other functions.

---

**Get in the habit of carrying your camera with you, so you'll be ready when photo opportunities present themselves. If you forget to bring your camera along, you can always rent one. It probably won't have all the features of the N70/F70 though.**

*Note:* The metering system and displays shut down approximately 8 seconds after the Shutter Release or other control button is last used. This conserves battery power. The camera will remain this way until you lightly touch the Shutter Release button.

## The F70D

As an alternative to the standard model, the F70 is also available with a databack as the F70D in some countries. This device prints the date or day and time in the lower right corner of the image (in horizontal format), useful for vacation photos and family events. If you do opt for this version of the camera, you may find it annoying after a while to have the date printed on every single frame. Try using the feature more selectively, for example, on the first frame of each roll, the date printing capacity can be a valuable feature.

The F70D also offers a panoramic function controlled by a switch on the bottom of the camera back. Sliding the switch in the direction of the arrow activates the panoramic function. Format indicators appear in the viewfinder to assist composition.

# Basic Concepts of SLR Photography

At this point, you may be getting eager to move along, and take photographs. You could easily do this almost immediately by setting the N70/F70 to one of its basic modes. But you'll benefit by taking the time to learn certain aspects of photography, including terminology and the N70/F70's unique features.

Until these are understood and you feel comfortable with the N70/F70's controls, you'll probably be taking only snapshots. If you want predictable results or photos you can proudly display, do consider the important facets of photography. These will help to illustrate the value of the many functions of this Nikon camera and how they can be used to translate your vision onto film.

## The Focal Plane Shutter

It is the focal plane shutter that makes today's single lens reflex cameras possible. It provides a "darkroom" in which the film is enclosed in the body without exposure to stray light. However, you should still not point the camera directly into the sun without a lens mounted on it, as light leaks may occur over time.

The focal plane shutter actually consists of two shutter curtains. The first curtain opens to expose the film, the second follows to

When the camera back is open, the thin blades of the focal plane shutter are exposed. They are extremely delicate and care should be taken not to touch them.

**A short shutter speed should be used to freeze motion and portray the subject sharply. The faster a subject is moving, the faster the shutter speed must be.**

end the exposure. The reference to shutter speed is not literally a measure of how fast the shutter is moving; rather it is the amount of time that elapses before the second curtain is activated to cover the film. With speeds faster than 1/125 second, the second curtain starts moving while the first is still traveling. At very high shutter speeds, such as 1/4000 second, the distance between the two curtains is only a thin slit which moves across the film. At shutter speeds slower than 1/125 second the shutter opens completely.

The N70/F70's shutter curtains are made up of narrow blades that travel vertically across the shorter side of the format. They are clearly visible when the camera back is open.

**Note:** Be careful not to touch these sensitive surfaces! One of the authors (PKB) recently spent a small fortune replacing a shutter assembly because of carelessness.

Using long shutter speeds to photograph moving objects produces a feel-ing of motion. For this photo, the camera was set-up on a tripod so all stationary objects were sharp and cars moving in front of the camera left light trails.

The N70/F70's shutter offers electronically-controlled speeds between 1/4000 second and 30 seconds allowing the photographer a wide range of possible exposure settings. Do note an advantage over most Nikon cameras: shutter speeds can be set in 1/3-stop increments in Auto Multi Program (P), in Manual (M) and Shutter-Priority (S) modes. In M, there is an additional setting, B (for bulb). The shutter stays open while the trigger is depressed in this setting, making long, timed exposures (as for fireworks) convenient.

**Note:** In "B", there is no metering guidance provided. Read the tips packed with rolls of film and articles in photo magazines to help determine exposure times. Extremely long exposure times reduce battery life because there is constant drain. Also, one should use a cable release and mount the N70/F70 on a tripod for

long exposures. This allows the camera to be triggered without jarring it, eliminating the risk of image blur from vibration.

### Choosing Shutter Speeds

The shutter speed determines how long the film will be exposed to light. In addition, it determines how motion is portrayed in a photo. If, for example, the shutter is open for a full second and your subject moves during the exposure, it creates motion blur.

The higher the shutter speed selected, the lower the chance of blur. If the exposure is taken at 1/500 second or higher, even a fast moving subject, such as a runner, will be sharp. Shutter speed is an important component in image creation. Applied carefully, it can show moving objects with a slight motion blur at 1/60 second, for example. At 1/1000 second or higher, motion will be stopped: the high jumper or water droplets will be "frozen" in mid-air, for instance.

You must also take into account the effect of your own movement on image sharpness. If you're holding the camera and using a slow shutter speed, hand and body tremors will shake the camera, precluding a sharp picture. The slowest shutter speed for hand holding is generally considered to be 1/60 second or the reciprocal of the focal length of the lens in use; whichever is faster. For example, with a 135mm lens, the slowest shutter speed would be 1/125 second. If you wanted to use a slower shutter speed, mount the N70/F70 on a tripod or rest it on a stable surface. If the shutter speed is too slow for the subject's motion, you may get a blurred subject against a sharp background. That may or may not be exactly what you intended. Motion blur can be a creative effect also, if well-executed.

**Note:** When working in full shutter speed increments, each slower speed allows the shutter to remain open for twice as long. Hence, 1/60 second is a time span which is twice as long as 1/125 second. Conversely, 1/500 second is half as long as 1/250 second.

## Aperture: The Light Value

Unlike "point-and-shoot" compact cameras, the N70/F70 also allows full control over the aperture of the lens. Increasing or

decreasing the size of the opening is another means of controlling the amount of light that will strike the film. This concept is similar to the functioning of our eyes: the pupils also open and close depending on the amount of light. Built into each camera lens is an iris diaphragm which adjusts the size of the opening.

The aperture controls the amount of light that reaches the film. The shutter controls the length of time light is allowed to enter. When taking a picture, we can adjust either the shutter speed or the aperture or both. By doing so we increase or decrease the film's exposure to light. In this manner, the two control elements work together, complementing each other. You can allow the N70/F70 to automatically control these variables. Or you can control one, or both, as we'll explain in detail later.

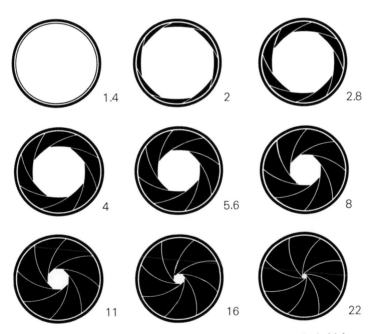

**F/number increases as aperture size decreases. Each progressively higher f/number represents a 50% (one stop) reduction in the amount of light reaching the film.**

# Demystifying f/stops

For the sake of consistency, we need references for the size of the aperture opening. Over a century ago, a series of numbers, called f/stops, was developed for just this purpose. The f/stop series is a mathematical progression and runs as follows: f/1, f/1.4, f/2, f/2.8, f/4, f/5.6, f/8, f/11, f/16, f/22, f/32 and up. However, all of these f/stops are not available on every lens. Each higher number in the series denotes an aperture opening that is half as large as the one before. Each progressively smaller (or lower) f/stop number denotes an aperture opening that is twice as large. So, f/8 is twice as large an opening as f/11. Conversely, f/16 is twice as small as f/11.

In other words, f/1.4 is a wide aperture, and f/32 is minuscule in comparison. The size of the aperture opening diminishes gradually as you work your way up the f/stop scale. Thus, f/16 is smaller than f/5.6. The larger the number, the smaller the opening.

This is one aspect of photography that most people find difficult to remember. Study the diagram in the book and refer to it as necessary, until this concept is clear.

In a subsequent section, we will discuss exposure control: how the relationship between aperture size and shutter speed affects the brightness of the photographic image. But first, let's consider some other terminology and concepts which will be required for a full appreciation of exposure.

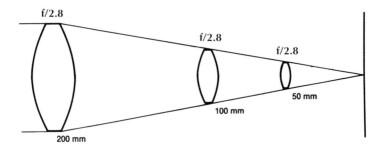

**As a lens' focal length increases, the diameter of the lens must also increase to allow the same amount of light to reach the film.**

## Defining Lens Speed

In photography, we often mention wide apertures (small f/numbers like f/2.8) and small apertures (large f/numbers like f/16). Aperture is used to define the speed of a lens. A "fast" lens has a wide maximum aperture, such as f/2.8 in a telephoto as compared to one of f/5.6 in a smaller, cheaper model.

One glance at the AF Nikkor line-up makes it clear that a fast lens must have a lens barrel of greater diameter to accommodate the assembly. The AF-I 300mm f/2.8, for example, has a much larger diameter than the AF 300mm f/4, whose widest aperture is only half as large. This factor also affects price: the wider the maximum aperture, the more expensive the lens will be.

The current trend to more compact zoom lenses was made possible by compromising maximum aperture size. The N70/F70's "standard" lens, for example, is the AF 35-80mm f/4-5.6 D. At a focal length of 35mm, this lens offers an aperture of f/4, acceptably wide for photography in overcast conditions without flash. Zoom up to 80mm, however, and the lens achieves a mere f/5.6, quite small in comparison to many other lenses. You've lost an entire stop of light. The N70/F70 may now suggest the use of flash.

**Note:** To prevent having to use slow shutter speeds and risk the possibility of blur, "slow" lenses like this often require a faster film. The more sensitive ISO 200, for example, requires only half the light needed by its ISO 100 counterpart. Since today's superior ISO 200 and 400 print films produce enlargements of acceptable quality up to 8 x 10 or 11 x 14 inches, there is less need for "fast" lenses (f/1.4 to f/2.8). That's because these "fast" films allow for faster shutter speeds even with affordable, small "slow" lenses (-those of modest maximum aperture).

Unlike some brands, AF Nikkor lenses still have aperture rings. The N70/F70 needs this mechanical part because the aperture is set manually using the ring in Aperture Priority and Manual modes. Other modes use the Command Input Control dial to set the aperture electronically, as we'll see.

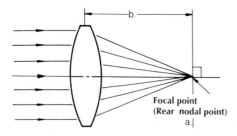

Focal length, marked "b", is defined as the distance from the optical center of the lens to the rear nodal point when focused at infinity.

Focal point
(Rear nodal point)
a.

## Focal Length and Angle of View

Along with the terms "shutter" and "aperture", the term "focal length" must be understood in learning photography. The technical definition of focal length is the distance (measured in millimeters) from the lens' rear nodal point to the film plane with the lens focused at infinity. However, it's not particularly important to know this, unless you're going to study optics. It is important to understand the effect of focal length on image formation.

The reference point in 35mm photography is 50mm, the so-called "normal" focal length. Its angle of view is approximately the same as that of the human eye so it produces a "natural-looking" perspective. Lenses of shorter focal length are called wide-angle and those which are longer are referred to as telephoto. When shooting from the same distance, wide-angle lenses make objects look relatively small because of their short focal length. Long telephoto lenses make things appear relatively large.

Focal length also determines the size at which an object is reproduced on film. A 200mm lens covers only half the area of a 100mm lens but it provides twice the magnification (actually, doubling any focal length achieves roughly the same effect).

When we refer to focal length, we must also consider the angle of view that the corresponding lens covers. A short focal length such as a 24mm offers a wide angle of view, denoted in degrees in the specifications chart. Conversely, a long focal length records a narrow angle of view. Thus, the term "wide-angle lens" can be readily appreciated. This wider angle of view will include more of a scene in the frame than a longer lens will, from any given camera position.

A primary advantage of SLR cameras such as the N70/F70 is the complete optical freedom and numerous creative possibilities

offered by the wide variety of interchangeable lenses available. These range from the so-called "fish-eye" that records everything in its 180 degree angle of view to extreme telephoto lenses, such as the 600mm. With the latter, you can produce a close-up portrait of a distant eagle on a limb or catch a baseball player's expression as the bat connects with the ball.

AF Nikkor zoom lenses offer the greatest versatility, encompassing a broad range of focal lengths in a single barrel. A push or a turn of the zoom collar will noticeably change the magnification and the amount included in the frame.

# Exploring Depth of Field

Depth of field is another term that crops up in photography. Depth of field is best defined as the zone of acceptable focus which extends beyond and in front of the point of focus. It can be thought of as the distance within a scene that appears sharp in a photograph, and it can vary greatly. It can be extensive, encompassing a great distance, or it may be only a few inches, as in macro photography. Understanding how to control and utilize depth of field will take the N70/F70 owner from snapshooting into the realm of creative photography.

### Depth of Field Factors

An optical system can show only a single, flat plane in critically sharp focus. Therefore, in any photo, only subjects at the focused distance are actually razor sharp. However, depth of field can be controlled by the photographer to produce a zone of acceptable sharpness behind and in front of the point of focus. The principles governing depth of field can be summarized in four points.

***As aperture size decreases, depth of field increases:*** To think of this in terms of f/number; depth of field is directly proportional to f/number. Doubling the f/number doubles the depth of field.

At a wide aperture of f/2.8, the zone of apparent sharpness will have considerably less depth than at f/16, for example. Only the primary subject will appear razor sharp, with its surroundings blurred to some extent. Conversely, the smaller the aperture, the greater the depth of field. At f/32, objects in both the foreground and background will be rendered acceptably sharp.

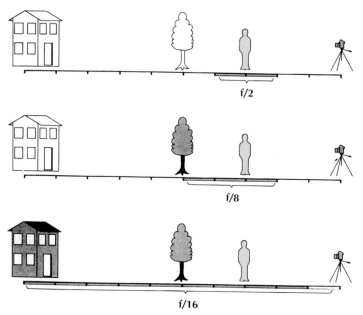

**The smaller the aperture (opening), the greater the area which is reproduced in acceptably sharp focus - the so-called, depth of field.**

*Longer focal length lenses produce shallower depth of field:* At the same aperture and distance from the subject, a 200mm lens will produce shallower depth of field than a 35mm lens. To confirm this point, take a picture of a person 8' away with each lens set at f/5.6.

With the 200mm focal length, only the subject will be in precise focus in your picture; the distant background will be blurred. With the 35mm lens, much of the surroundings will be acceptably sharp as well. Your creative intentions will determine the right focal length. Telephotos are most useful when you want the viewer's attention riveted to the center of interest without competing elements sharply rendered.

*Note:* There is one exception to this rule, which occurs in extreme close-up (Macro) photography. The focal length no longer affects the depth of field in the macro range. Whether you use a Micro

Nikkor 60mm or 200mm lens, depth of field is the same at high magnification.

***The closer the subject, the narrower the depth of field:*** Depth of field increases dramatically as camera to subject distance increases. With any lens, focus on a tree 30' away and others in the frame will be acceptably sharp as well. Some of the trees closer to the camera, and others behind the focused point, will fall within the depth of field. Now set focus on a tree only 5' away. Only this single tree will be rendered sharp in the final picture.

***Note:*** In both cases, the actual range of acceptable sharpness will vary based on the factors mentioned in the first two concepts.

***Depth of field generally extends one-third in front of the point of focus, and two-thirds behind it:*** Maximize the depth of field by focusing one-third of the way into a scene at any given f/stop. See the diagram on page 32 as an illustration of this point.

***Note:*** Again, this factor is true with all but extreme magnification as in macro photography with a Micro Nikkor lens. Depth of field is roughly equal on both sides of the focused point in high magnification work.

**Varying Depth of Field**

The effects of depth of field on the image are considerable. Manipulating this factor, using the aperture and focal length, is one of the most useful creative tools the photographer owns. Imagine a portrait with a busy background - the trees, weeds, poles and cars all appear quite sharp. This effect was achieved in one of three ways: with a small aperture (like f/16), a wide-angle lens, or a great distance from the subject (or some combination of these three factors.)

Prefer a cleaner look with soft blurring eliminating the obvious clutter? Switch to a longer lens, move in closer and open the aperture to f/4, for instance. Shallow depth of field will de-emphasize the secondary elements in the frame.

In an environmental portrait, however, you may decide to maximize depth of field. In this case, the blacksmith and the tools in his workshop will all be reproduced in sharp focus. A 28mm lens

at f/22 will create an effect which could never be matched by a telephoto lens with its shallower depth of field and narrower angle of view.

Or, consider a landscape, including foreground bushes, an S-curve of a river in the mid-ground flowing toward distant peaks rising majestically into the sky. Apply the first three factors and you will minimize depth of field. Only the subject you focused on will appear sharp in the final picture. Not the intended effect? The solution is easy. Switch to a wide angle lens, (perhaps 28mm), and stop down to a smaller aperture (perhaps f/16). Set focus for the rocks 1/3 of the way into the scene. Now, the depth of field will be far more extensive, keeping the focus over the entire scene acceptably sharp for a full appreciation of its beauty.

### Previewing Depth of Field

The SLR viewfinder provides accurate framing but can deceive you in one respect. *No matter what f/stop you select, the viewfinder always displays the image at the maximum aperture.* This is intentional to offer the brightest view possible on the screen.

Unfortunately, depth of field always appears shallow. With any given lens, you'll notice no difference when switching from f/4 to f/22. However, the two final pictures you take will look quite different.

In the more expensive cameras such as the N90/F90 series, Nikon incorporates a depth of field preview feature. This switch forces the lens to stop down to the set aperture allowing you to see the range of apparent sharpness. This is not included in the N70/F70, perhaps to keep the price down.

From our perspective, this omission is unfortunate. The ability to prejudge the range of apparent sharpness can be useful. On the other hand, if you remember the tips in earlier sections, and experiment with each one, you can become proficient at estimating depth of field.

## Exposure Control

The two control systems, shutter speed and aperture, complement each other perfectly. As mentioned, the settings for both follow equal, equivalent progressions. Consequently, a broad variety of

shutter speed and aperture combinations can produce exactly the same exposure. The brightness of the photo will be identical, but depth of field and the depiction of motion will vary. This offers the photographer great creative freedom, even in the autoexposure modes.

## Exposure Control Analogy

The term "equivalent exposure" was hinted at in the above paragraph. Perhaps the most useful means of clarifying this essential concept is to use the following analogy: Suppose we have a tap to which several hoses are attached and we want to fill a child's swimming pool. With a hose of small (1/2") diameter, it would take 10 minutes. Switch to one of double the diameter (1"), and it will take half as long, or 5 minutes.

In photography, we want to properly expose a frame of film. We can do that by controlling the diameter of the opening (aperture). Or we can vary the length of time the light should strike the film (shutter speed). Just as it takes "X" amount of water to fill the pool, it takes "X" amount of light to produce a nicely exposed picture. The camera's built-in light meter provides plenty of guidance in this regard.

Proper exposure can be achieved no matter which variable you control: the size of the opening through which light flows, the length of time it is allowed to flow onto the film, or both. These choices should be made according to creative intentions and how the subject should be portrayed.

## Equivalent Exposure

Let's switch to an actual photographic example to illustrate several of the concepts described so far. In this example, we are shooting a flowing stream using an AF Nikkor 85mm f/1.8 D lens. For the first shot (picture A), we will select 1/15 second at f/16, a combination that the light meter of the N70/F70 suggests will provide correct exposure. Naturally, the camera will have to be mounted on a tripod for this shot. For the second (picture B), let's choose an equivalent exposure using a fast shutter speed, 1/1000 second at f/2.

In both cases, the exposure (image brightness) will be the same. When we "shortened" the exposure time, we compensated by opening the aperture the same number of increments or stops, six in this example. Check the f/stop series in the section "Demystify-

ing f/stops" and you'll find a six-stop difference between f/2 and f/16. Each of the two combinations will produce a very different picture, however.

In picture A, the water is depicted as smoothly flowing, a soft white blur among the stationary rocks and trees. This contrast captures the essence of movement very well. This was achieved by the long (1/15 second) exposure time. The small aperture (f/16) has rendered the foreground branches and the background trees quite sharply, as expected.

Picture B has a different effect. The previously romantic flow of the water is "turned to ice." Each drop is clearly defined, frozen in mid air. This impression is foreign to us because our eyes perceive movement; they cannot "freeze" individual phases of motion. The wide aperture (f/2) has reduced the depth of field drastically. The background trees are a soft green blur, while the leaves in the foreground have dissolved into mere blobs of color, an effect which can sometimes be quite pleasing.

**Equivalent Combinations**

The two extremes in our example represent the range of creative freedom in photography. The following chart demonstrates the various combinations which are possible in the hypothetical situations described in the previous section. Each would have provided equivalent exposure:

| | | |
|---|---|---|
| 1/15s | and | f/16 |
| 1/30s | and | f/11 |
| 1/60s | and | f/8 |
| 1/125s | and | f/5.6 |
| 1/250s | and | f/4 |
| 1/500s | and | f/2.8 |
| 1/1000s | and | f/2 |

In truth, many other combinations are possible with the N70/F70 because exposure settings are not limited to one-stop intervals. However, for the sake of simplicity, the above should suffice to illustrate the concept.

**Note:** As previously mentioned, each larger shutter speed is twice as long as the one before. Therefore, 1/60 second produces an

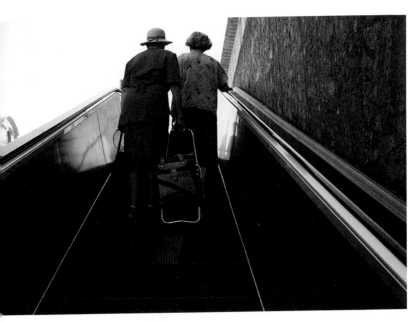

**Matrix metering is excellent for shooting candid pictures and snapshots. The N70/F70 correctly exposed the subject in spite of the dark foreground and bright sky. For this photo, using a wide-angle lens overemphasized the perspective of the escalator.**

exposure time twice as long as 1/125 second (and vice versa for shorter exposure times). And each change in aperture size doubles or halves the size of the opening.

Consequently, a one-stop longer exposure time requires a one stop smaller aperture to maintain an equivalent exposure. A six stop increase to wider apertures requires a six stop reduction in the shutter speed. Other than in Manual mode, the N70/F70 automatically sets the corresponding f/stop or shutter speed as you change the other of these two variables.

The simplest means of switching among various combinations without changing the exposure itself is Program mode. With the N70/F70, turning the Control dial shifts the shutter speed/aperture combination in 1/3 stops. No matter which combination you select, the exposure will be the same. However, depth of field and image sharpness will vary substantially in the final photo, as we have described.

# Preparing to Shoot

To prepare a new camera for shooting there are a number of things that have to be done, most only once. After that, you generally just have to take the lens cap off, turn the camera on and select the exposure mode.

## Loading the Battery

The N70/F70 is designed to accept two 3 volt CR123A lithium cells. According to Nikon specifications, one set of fresh batteries will power approximately 115 rolls of film (24 exposures each) at 68° F (20°C). If you use flash for half of the pictures, the battery capacity is reduced to 25 rolls.

**Note:** The above estimates are optimistic as with every camera of every brand. That's because the test conditions can never be duplicated in real-world photography. Then, too, several variables come into play: the amount of autofocusing, the time spent with your finger on the Shutter Release button, the amount of flash power expended in any situation, etc.

Lithium batteries, such as the CR123A, are more expensive than the standard alkaline AA's used by some other Nikon's, but offer several advantages: lesser weight/size, quicker flash recycling and longer life, especially at low temperatures.

To load the batteries, take the following steps:
1. Make sure that the main switch is OFF.
2. Open the battery compartment lid on the bottom of the hand grip.
3. Push the batteries into the compartment so that the polarity of the batteries matches the sketch inside the battery compartment.
4. Turn the camera on. A full battery symbol should appear at the top left of the LCD panel. Touch the Shutter Release button and the other symbols will appear as well.

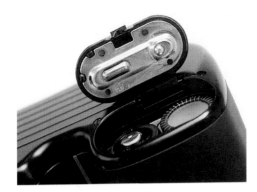

**Two lithium batteries slip into the chamber, inserted with the correct polarity as noted on the cover.**

If a half-full battery symbol blinks in the LCD panel, the batteries are weak. If an empty symbol flashes, they are just about dead. If the LCD panel remains blank, the batteries are either dead or incorrectly installed. Always turn the camera off to change batteries. The battery symbol on the external LCD displays the battery situation each time you turn the N70/F70 on or touch the trigger.

*Note:* Low temperatures reduce battery life to 80 rolls at 68°F (and 20 rolls if flash is used for 50% of the pictures) according to the Nikon specs. So try to keep the camera as warm as possible when not taking pictures. Keeping it under your parka in winter, for example, will improve battery response. Also, for cold weather shooting, always have a set of spare batteries in a warm inside pocket. Again, Nikon's estimates are optimistic!

Make sure that you replace both batteries at the same time. If one battery has less capacity remaining, it will quickly drain the other. Also, never mix batteries of different manufacturers or different power levels.

## Loading the Film

It's no secret that film is sensitive to light. For precisely that reason, the film chamber of the N70/F70 is light-tight. In direct sunlight, try to shade the camera when film is being loaded or unloaded. The light-tight film cassette does provide a degree of

protection but bright sunlight really puts it to the test, especially with an extremely light-sensitive film, such as ISO 1600.

When you open the camera back, you will notice six contacts on the left side of the cassette slot. The camera uses them to read information (ISO, length, etc.) encoded in the checkerboard pattern on the film cassette. Avoid touching these contacts! As a matter of fact, the entire interior of the camera deserves very careful treatment. When the back is open, the extremely delicate shutter curtains over the image window are exposed. One slip of the thumb will destroy the focal plane shutter.

Before you load the film, pull the leader out of the cassette a little more. If you do this after you have loaded it, you run the risk of touching the shutter by accident. Don't be overly concerned about pulling the film out too far, it can be easily pushed or rolled back a little.

The film must reach exactly to the red indicator on the opposite side, laying nice and flat. Now you can close the back by pressing it lightly. Turn the camera on. Pressing the Shutter Release button automatically advances the film to the first frame.

If the film failed to load properly, there is no risk of shooting without actually taking pictures. You can press the trigger as much as you want, but nothing will happen. You'll notice right away that something is amiss; open the back of the camera again and restart the entire film loading process.

**Checking or Modifying Film Speed**

The checkerboard pattern on the film cassette is called the DX code. As long as you are using DX-coded film with a speed between ISO 25 and 5000, the N70/F70 sets the film speed automatically. If the film is not DX-coded, you can set the correct ISO by pressing the Function button and using the Control dial to scroll to the ISO/DX section on the LCD panel. Then hold the SET button and use the Control dial to select the appropriate film speed.

You can verify the film speed at any time by pressing the Function key and then the SET key and it will be displayed on the LCD panel. You can verify the type of film loaded through the small window in the camera back.

You can override the automatically-set film speed at any time. Many photographers intentionally underexpose transparency (slide or chrome) film from 1/3 to 1 full stop for more saturated colors.

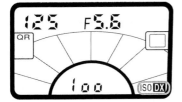 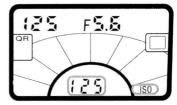

The LCD panel clearly denotes that the camera will automatically set the ISO using the DX coding on the film cassette.

The photographer can also set the film speed manually to override the DX coding and for non-DX coded films. The only reminder is the absence of the letters DX on the LCD panel, so checking the film speed is recommended every time a new roll of film is loaded.

Do this, also, if you want to "push" an entire roll. "Pushing" film occurs when a photographer intentionally exposes a film at a higher ISO rating. The film is then developed to adjust for this. For example, ISO 100 slide is shot at a setting of ISO 200 and the processing time is extended to compensate. The final image should be properly exposed. You can set any film speed between ISO 6 and 6400 manually by using the Function and SET keys as well as the Control dial.

*Note:* Any manually-set ISO remains in effect even after a new roll is loaded. This can be an advantage for consistency when shooting dozens of rolls of the same film at one time. But it is also risky, such as when switching from an ISO 100 to 400 film. *Therefore, you should always check the film speed - as described above - each time you load a new roll!*

**What does film speed indicate:** A film's "speed" is an indication of how sensitive to light a film is; the higher the number, the more sensitive the film. Hence an ISO 200 film is more sensitive to light than an ISO 100 film. To be more precise, it is twice as sensitive and requires only half as much light for proper exposure. Conversely, an ISO 200 film is only half as sensitive as an ISO 400 film. A very light-sensitive film is considered to be a "fast" film, while "slow" films have a low number and require more exposure.

**Film Transport and Rewind**

The N70/F70 automatically advances the film by one frame after each exposure without the need to remove the camera from eye level. It's ready for the next shot immediately. This is often an advantage in the field or in portraiture because a more interesting or photogenic scene will often present itself right after you take a shot.

But the N70/F70 can do much more. It can be set to expose a series of frames in sequence as long as you maintain pressure on the trigger. To set Continuous film advance, go to the function section on the LCD panel, which is second from the right. When you press the SET key, you can switch from the normal "S" (single frame advance) to three other options using the Control dial. If you turn the dial counterclockwise, an "L" (for "Low") appears, denoting the quiet 2 frame per second (fps) advance. One step further, at "H" (for "High"), provides advance at up to 3.7 fps.

The latter assumes a shutter speed of at least 1/250 second (at normal temperatures, with fresh batteries). At 1/250 second there is enough time for a high advance rate, which is not possible with slow shutter speeds, of course.

When the end of the roll is reached, camera operation stops. The word "End" flashes on the LCD panel and in the viewfinder to make the situation clear to you. If you press the "IN" and "Ps" buttons simultaneously, the rewind process starts and the frame counter runs backwards. The film leader is wound completely into the cassette. This is intended as a security measure so that you cannot load a previously exposed film by mistake and shoot it all over again.

The N70/F70's rewind function is fairly quiet. However, if even this little bit of noise creates a disturbance (such as at a wedding or golf match), you can switch to whisper mode. The symbol "SL" (for silent) is included in the film transport function range. This hushed operation is extremely quiet but the process takes a little longer.

After the film is rewound, "E" appears on the LCD and the film symbol flashes for a few seconds. You can open the back and remove the cassette top end first. If the camera prematurely stops rewinding because of weak (or cold) batteries do not open the back under any circumstances! The unprotected film would be ruined by light. It is far better to turn the camera OFF and change

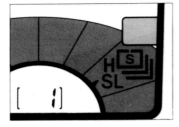

There are several film transport options: Single Shot, Continuous Low, and High speed, as well as silent rewind (SL) mode.

the batteries. You can then restart the rewind process. If there are no spare batteries available in the cold, allow the original batteries to warm in a pocket. They should then be able to power the final rewind.

### Switching Film Mid-Roll

In some cases, you may wish to rewind mid-roll to switch to a different film type (follow the same procedure detailed above). When you later want to reload the partially-completed roll, you'll face a problem: the film leader has been pulled all the way into the cassette. You'll need to retrieve the leader to reload. Ask any film lab to do so for you or purchase one of the many "film leader retriever" gadgets available from well-stocked photo retailers.

*Hint:* After rewinding a partially exposed roll of film, write the last frame number on the cassette (on a piece of masking tape, perhaps). When you want to load it again, set the camera to "M" (manual mode) and to manual focus (M/F). Select the smallest aperture (f/16 or f/22) and the fastest shutter speed (1/4000 sec.) and put an opaque lens cap in place. Then, press the trigger while covering the viewfinder window (to prevent light from entering). Stop when the original frame number is reached. To be safe, add one frame to it so that there is no chance of image overlap.

## Mounting and Removing the Lens

The N70/F70 is designed for use with AF Nikkors lenses which enable the use of automatic focusing and Matrix metering. However, the N70/F70 will also accept manual focus Nikkor AI and AI-S lenses, with some loss of camera capabilities. We will discuss the various options in detail in a subsequent chapter.

To mount a lens, turn the camera off and remove the body cap as well as the rear lens cap. Leave the front lens cap on for the moment as protection against fingerprints. Now align the index mark of the lens - usually a white line - with the white dot on the left side of the camera. Mount the lens and turn it to the left until it locks into place. Do not press the lens release button on the camera body until you are ready to remove the lens.

To remove the lens, put the lens cap on first and hold the camera with your left hand. Now grasp the lens with your right hand so that your index finger ends up on the lens release button. Turn the lens to the right to disengage and remove it.

Put the rear lens cap on immediately to protect the mechanical and electronic contacts. Always rest a lens on its capped, front element, unless you are using a fish-eye with a rounded front element. The back end of the lens has all kinds of contacts and levers that should not come in contact with hard surfaces. Nikon warns against pressing the shutter release while mounting a lens to prevent activating a lever prematurely.

If you use the N70/F70 with several lenses and carry it in your gadget bag without a lens attached, order an opaque body cap right away. This one bayonets into the mount and will not fall off. The transparent cap that comes with the camera is made of soft plastic, intended for shipping only. It will frequently fall off the body exposing the delicate interior to the risk of damage.

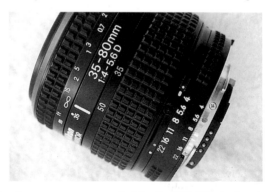

**AF Nikkor lenses are recommended for the N70/F70. In Aperture-Priority and Manual mode, the aperture is selected manually on the ring, at f/4 here. In Program and Shutter-Priority modes however, the ring is locked to the largest f/number.**

## Final Preparations

There are still two remaining tasks to complete before shooting. First, the aperture ring on the AF Nikkor lens should be set for the largest f/number, often f/22. Lock it into place by sliding the small lever in front of the aperture ring.

**Note:** This is not required if you plan to shoot in Manual or Aperture Priority automatic because apertures are set using this mechanical ring. In other modes, f/stops are selected automatically or with the Control dial. *Thus, the aperture ring must be locked to the largest f/number.* If you forget to do so, "Err" flashes in both display panels as a warning.

Finally, check the AF/MF switch on the body. Set it for AF if you plan to shoot with autofocus, although you may prefer manual focus (MF) for some situations. Given the highly reliable AF system of the N70/F70, autofocus will generally be the best choice for the vast majority of subjects.

## Practicing the Right Stance

No matter how advanced the N70/F70's computerized systems may be, sharp pictures require a steady grip. Holding the camera improperly will lead to disappointing results. To maximize the chances of a sharp picture, try the following:

Hold the grip with a relaxed right hand and rest the index finger gently on the Shutter Release button. When taking the picture, additional gentle pressure should be used. Jabbing the button would produce motion blur as the camera would not remain steady. This tactic alone can sometimes make the difference between sharp and fuzzy images.

Stand in front of a mirror to practice the right stance. Cradle the lens in your left hand for additional support. Encircle the barrel with the left thumb and index finger. Press the camera gently against your forehead while looking through the viewfinder. Try the sharpshooter's trick: exhale and hold your breath when pressing the trigger.

More importantly, tuck your elbows in at your sides and spread

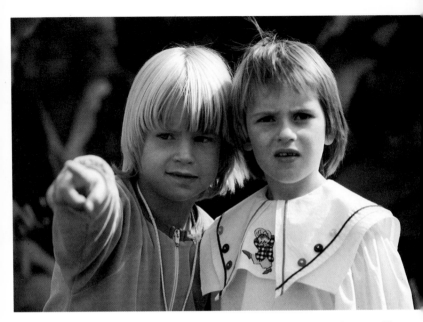

Use a telephoto zoom lens to take candid photographs of children. It will allow you to keep some distance between yourself and the subject so you aren't a distraction. The zoom feature offers greater control over composition.

your legs apart in a comfortable stance. This creates a human tri-pod, creating a rigid support. For vertical compositions, one elbow may be up in the air (depending on the direction the camera is rotated), but keep the other one tucked in. If possible, find some firm external support: rest your elbows on a car roof, lean against a door frame, or rest the camera on a fence railing for greater stability.

To get full performance from your excellent Nikkor optics, remain conscious of the shutter speed. For handheld work, it should be at least "one over the reciprocal of the focal length". This means 1/60 sec. with a 50mm lens, 1/250 sec. with a 200mm telephoto, and 1/500 sec. or higher with a 300mm or longer lens. High shutter speeds are possible with a faster film such as ISO 400. Otherwise, use flash, a tripod, or one of the techniques pro-vided above to reduce camera shake.

# Focusing With the N70/F70

Thanks to the SLR principle used in the N70/F70, one glance through the viewfinder confirms exactly what is in sharpest focus. The plane of sharpness is visible on the viewing screen at all times. This is quite different than with the simple point and shoot cameras. With those, everything always appears in focus through the small window.

The exception is when shooting with ultra wide-angle lenses (24mm or shorter). Depth of field is so extensive that the exact plane of focus may no longer be identifiable. That makes critical focus more difficult; switch to autofocus or use the distance scale on the lens to set focus manually in MF. Frankly, small focusing errors are masked by the extensive depth of field. The above only holds true for wide-angle lenses.

## Automatic Focusing

Autofocus has become standard in 35mm cameras since the technology was refined a few years ago. The N70/F70 employs Nikon's latest AF system employing the CAM 274 module with 274 CCDs (charge coupled devices). This is a "Cross-type" autofocus module with a 7mm wide horizontal plus a 3mm high vertical detection area. A cross sensor offers definite advantages over a purely horizontal module, in detecting patterns of an infinite variety.

Like most SLR cameras, the N70/F70 uses a "passive" autofocus principle. In other words, it does not emit a beam (as do the active systems of compact cameras) to measure the distance to the subject. Instead, technology called "phase detection" is employed. Each of the pairs of sensors views the subject independently. The AF computer then compares the images recorded by each to determine whether they are in phase or identical.

If so, the subject will be sharply rendered. If not, a microcomputer instructs a motor to move the lens elements to the correct positions to focus on the subject within the AF brackets on the viewing screen. With the N70/F70, the focus operation is set in

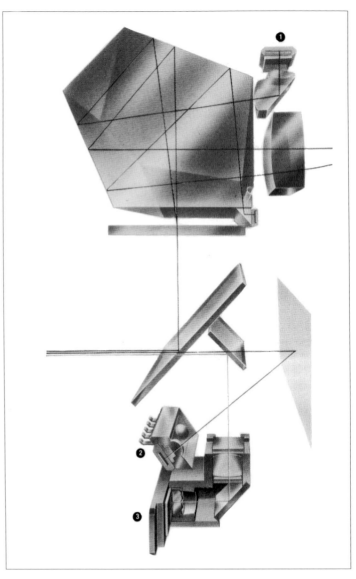

Optical Path in the N70/F70:
① Eight-segment Matrix Sensor, ② Five-segment TTL Multi Sensor,
③ Cross-type Autofocus Sensor.

motion while the calculation is still taking place. Consequently, the entire process is much faster than in older AF cameras such as the Nikon F4.

*Note:* Just like your own eyes, the module requires contrast or texture and a minimum brightness level. This explains why AF is not totally "foolproof" any more than our eyes are "perfect".

### Nikon AF Technology
The AF sensors are arranged on the floor of the mirror chamber. A section of the image cast by the lens is projected onto them. The reflex mirror must be partially transparent so that part of the light can travel downwards to the AF module.

The computer's software determines the speed and accuracy of the procedure. It tells the camera how to analyze the information it receives. The newly developed micro computer and software process focus data faster and more precisely than ever. A more powerful AF motor then assures that actual focus is achieved almost instantly.

In action photography, the AF system is capable of tracking subjects moving toward or away from the camera position. It is most successful with constant speed, however. Only the N90s/F90X can handle truly erratic motion successfully. Nonetheless, the N70/F70 will meet the demands of the serious advanced action photographer in 80% of common situations. Shooting a pro football game, stock car race or track and field event should be child's play for the Tracking Focus system at speeds up to 3 fps.

In our tests, the autofocus system of the N70/F70 was comparable to that of the more expensive N90/F90; high praise indeed. At the time of this writing, only the N90s/F90X was faster or more reliable.

## Focus Detection Specifics

The N70/F70's wide area (7mm) sensor is useful in two distinct situations. First, off-center compositions are simplified as long as part of the sensor covers the subject. In action photography, the Wide-Area sensor prevents "losing" a small target as it drifts slightly off center.

**Wide-Area focus detection is denoted by the two brackets in the viewing screen. The small circle indicates the Spot AF detection sensor. With the latter, precise autofocus is possible on a small portion of the subject. The larger circle denotes the area given emphasis in Center-Weighted metering mode.**

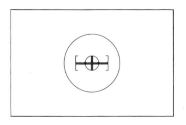

Nikon added the vertical (3mm) detection area in the middle of the frame to detect horizontal patterns which can frustrate other AF systems. The cross-type sensor can handle all situations as long as the lens has a maximum aperture of f/5.6 or wider. Some competitors' autofocus systems require f/2.8 or wider for cross-type detection, making this Nikon more reliable with many lenses. Since most zooms and other affordable lenses used by photo enthusiasts do not have wide maximum apertures, the Nikon AF system will be appreciated by many.

Some camera manufacturers use multiple point AF detection systems instead. The N70/F70's solid/wide detection area has advantages and disadvantages. First, the Nikon system is not frustrated by a small subject which might fall between the multiple points of another camera. However, the wide detection area may read varying distance planes so you cannot be certain which is in sharpest focus. Is it the subject's eye or her nose?

## Critical Focus Control

When critically accurate focus is required, switch the N70/F70 to the narrow Spot AF mode. Press the AF Field Size button [o] while turning the Control Dial to switch between the wide and narrow focus detection areas. The latter allows you to focus very precisely on smaller subject details.

This option is most practical when used in conjunction with AF Lock. Because the detection sensor is in the center of the screen, it results in a tendency to center every subject. To avoid such static compositions, set focus and then recompose with focus locked on the primary subject element.

An advantage of Wide-Area AF sensor is that it can even focus on an off-center object.

The N70/F70 switches to the narrow Spot AF detection sensor automatically when flash is in use. This is indicated in the viewfinder. Conversely, the autofocus field will automatically revert to the Wide-Area focus detection in the eight Vari-Programs. If you want to return to Spot autofocus when switching to another mode, you'll need to do so as per the procedure mentioned above. Turning the camera off does not affect the AF detection area selected.

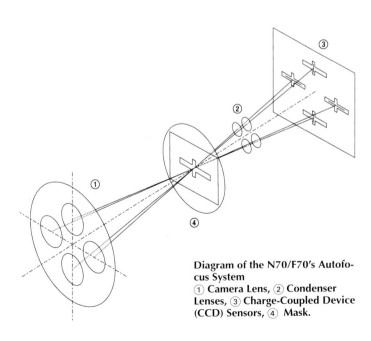

Diagram of the N70/F70's Autofocus System
① Camera Lens, ② Condenser Lenses, ③ Charge-Coupled Device (CCD) Sensors, ④ Mask.

## Two Autofocus Modes

Your N70/F70 will normally be in single shot AF mode (AF-S) called Focus-Priority Servo by Nikon. Here, focus is set as soon as you touch the Shutter Release button and remains locked until you fire the camera. Hence, there is no need to frame the final picture with the subject dead center in the screen. ("Servo" denotes tracking focus ability as discussed later).

An exposure will not be made until focus is achieved, assuring a high percentage of sharp pictures. Hence the term "focus-priority". Switch to Continuous Servo Release-Priority Autofocus (AF-C) and you can trip the shutter anytime. This is more useful for action photography.

To do so, turn the Control dial while holding the Function key until the little arrow appears in the third section from the left on the LCD panel. Turning the Control dial while holding the SET key switches between "C" (Continuous Release-Priority AF) and "S" (Single Servo Focus-Priority AF).

## Tracking Autofocus

When shooting moving objects, you want the system to track the subject, adjusting focus as its distance changes. The N70/F70 will do just that with "predictive" Tracking autofocus. This term warrants the following explanation:

There is always a delay from pressing the trigger to the moment the shutter finally opens (while the aperture stops down, mirror flips up, etc.) Though measured in milliseconds, this "time lag" can be significant. A skier can travel quite some distance during this interval. By anticipating the probable position of the subject at the instant of exposure, and focusing for that spot, predictive AF is far more successful than the simple Continuous AF of earlier cameras.

Unlike some camera models, the N70/F70 will automatically switch to Tracking Focus when motion is detected no matter which AF mode has been selected. If the object within the AF brackets (etched on the viewing screen) begins to move, tracking is activated. (In AF-S mode, remove your finger from the Shutter Release button first if Focus Lock is active at the time). Subsequently, the

**The Wide-Area AF field would not be best for this situation. It would have focused on the tree branches in the foreground which appear as areas of soft focus in the photo. Instead, focus on the person manually or use the Spot AF field and focus lock.**

system reverts back to normal operation. In AF-S mode, that includes Focus Lock, with pressure on the shutter release.

Practice this with children walking or cars approaching on your street, using both "S" and "C" AF options. You'll probably find that AF-C is more likely to respond instantly, making it preferable for action photography. But the auto-switching capability of the N70/F70 in AF-S mode is useful; it produces a higher percentage of sharp pictures than less sophisticated systems.

***Note:*** In Continuous AF mode, autofocus remains continuous at all times. It is not locked by pressure on the shutter release.

## Handling Focus Difficulties

You will occasionally find situations where the N70/F70 cannot focus due to system constraints. This is mainly due to the fact that the camera is dependent on comparing images (phase detection AF). Passive AF requires some contrast or pattern to achieve focus. Thus, wallpaper would be a more reliable target than a painted wall unless it is stucco.

The AF system is also frustrated by extremely bright targets such as reflections off water or chrome. Although the N70/F70 will focus in near darkness (on a subject lit by a single candle) it does require some light. In such cases, add an accessory Nikon Speedlight with an infrared light emitter. This will project a bright pattern on the subject as a target for the AF sensor of the camera.

What to do if the autofocus gives up and the lens starts hunting and searching aimlessly from one direction to the other? Or what if it insists on setting focus for the wrong subject, such as foreground leaves instead of the pond behind? One solution is to find a more reliable target at the same distance (perhaps a door frame instead of a flat wall) and set focus for that instead. Recompose with Focus Lock (slight pressure on the shutter release) and then shoot.

## When to Use Manual Focus

Naturally, you can switch over to manual focus anytime by setting MF on the focus mode selector. Then, turn the focusing ring on the lens until the primary subject appears sharp on the viewing screen. Or watch the focus confirmation signal in the viewfinder. If you can estimate distances, use the distance scale on the lens; this technique is most useful with wide angle lenses as described previously.

**Don't let the N70/F70 sit in your camera bag between vacations. Take it out with you on short walks or look for interesting subjects in your own yard. Practice using the camera's many features and try different techniques for focusing and metering in difficult lighting situations. Taking detailed notes and looking at your results with a critical eye towards technical accuracy and composition can help you improve your photographs.**

In some cases, you'll switch to manual focus in spite of the excellent Nikon technology. When shooting from a tripod, you normally point the lens and lock the tripod head. You do not want to change this composition in order to set focus (on a rock at the side of the frame for instance).

When shooting extreme close-ups with high magnification (as with a Micro-Nikkor lens) it's best to focus manually. Let's say you want to record the pistil and stamen of a tulip. Set approximate focus manually. Then shift the camera position (to and fro) in minute increments until the subject pops into sharp focus. If the camera is mounted on a tripod you'll need to move the entire assembly unless you buy a device such as a focusing rail. The latter allows for shifting the camera/lens in millimeters, ideal for reaching the exact position for critically accurate focus.

**Note:** In MF mode or with non-autofocus Nikkor lenses, the focus-assist signals in the viewfinder will still operate. (Nikon calls this the Electronic Rangefinder).

# Exposure Metering

Like all 35mm SLR cameras, the Nikon N70/F70 provides "TTL" or "through the lens" metering. A highly sensitive metering cell inside the mirror chamber reads light entering through the lens. Subject brightness (reflectance) and contrast is measured accurately, no matter what Nikkor lens is mounted, from wide-angle to telephoto.

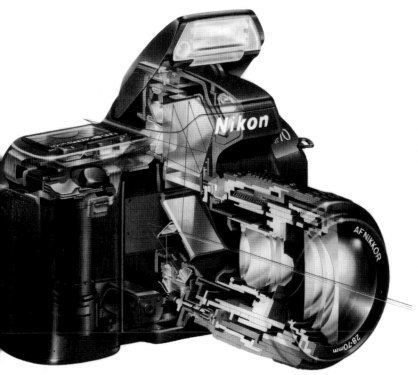

**A portion of the light entering the AF Nikkor lens is directed to the auto-focus sensors and the Matrix metering cell. The rest is reflected upward to the pentaprism and the eyepiece for accurate framing with the single lens reflex design.**

The N70/F70 offers three different metering options: center-weighted, spot, and Matrix metering. These include an option for every situation. Additionally, if circumstances warrant, the N70/F70's exposure can be manually set, using your judgment or an accessory light meter.

## Advanced 3D Matrix Metering

Matrix metering is Nikon's specialty. It was the first manufacturer to introduce this concept with the Nikon FA in 1983. That model was a resounding success, encouraging camera manufacturers to refine the technology. The N70/F70 includes one of the most advanced systems available. It is comparable to that of the N90/F90, one of the highest rated of all cameras in exposure metering.

Nikon calls its version of multi-segment technology "Matrix metering" after the matrix used to evaluate the results. With the N70/F70, the image area is divided into eight segments. The micro computer analyzes the brightness range recorded by each, compares the metered values from the individual sectors and evaluates them according to its stored "knowledge." The best exposure is set for the relative contrast in a scene. The metering system will ignore or limit emphasis on extremely dark, or bright, peripheral areas, such as the sun in a corner of the frame. In other words, it applies corrections in the blink of an eye that a professional would set manually after much evaluation of the scene. Of course, the boundaries are not as "infinite" as they would be with a real photographer. But this flexible technology is often much better than Center-Weighted average metering.

With D-type AF Nikkor lenses, the N70/F70 provides 3D Matrix Metering with Distance Data Detection. An encoder in the D lenses detects and relays camera-to-subject distance information to the metering computer. The Matrix system analyzes this data and makes the calculations necessary for correct exposure, even in extremely complex lighting conditions.

By evaluating distance in addition to brightness and contrast data, the odds of exposure accuracy are increased. This improvement is not dramatic because Advanced Matrix metering (with any AF Nikkor lens) was already so sophisticated. With print films,

it is unlikely that you'll notice any difference. With slides, certain high contrast situations will be more accurately exposed because the exposure is optimized for the subject in sharpest focus.

At press time, Nikon listed 23 AF Nikkors with the distance signal chip. This number will increase, assuring full access to a system of optics which can take maximum advantage of the N70/F70's high tech metering system.

### Evaluating 3D Matrix Metering

With D-type AF Nikkor lenses (for 3D Matrix metering), we were more impressed with exposure accuracy on bright days when the contrast between subject and background was especially high. In less dramatic situations, we found little difference between Advanced and 3D Matrix metering. The pre-production sample N70/F70 tended to meter for the shadows, producing perfect negatives in most conditions. With slide film however, a -1/3 EV Exposure Compensation was required to produce fully saturated colors.

The advantage of D-type lenses in flash photography is equally apparent, as we'll see later. The five-segment Multi-Sensor works in tandem with the Matrix meter, which evaluates ambient light. Hence, the subject is nicely exposed while the background is rendered bright (outdoors in daylight, or indoors in a standard-sized room in a home or apartment). With D-type lenses, 3D Multi-Sensor Balanced Fill Flash produced superior exposure accuracy in high contrast situations described later.

In conclusion, we would recommend D-type lenses for full 3D Matrix metering. However, we believe most owners will be highly satisfied with the results even if they use the N70/F70 with standard AF Nikkor lenses (with manual focus Nikkors, Matrix metering will not operate; the N70/F70 switches automatically to Center-Weighted metering).

### Fuzzy Logic Technology

While it may seem to be a contradiction in terms, "fuzzy logic" is a powerful form of artificial intelligence. Because the N70/F70's Advanced Matrix meter incorporates this technology, let's briefly examine its value in practical terms.

The primary advantage is the ability to make smooth transitions when effecting any changes in exposure. As the brightness level

**Principles of 3D Matrix metering:**
① and ② are meter readings from the individual sections of the matrix, ③ distance information provided by the lens, ④ position of subject (is the area of sharp focus centered) are all taken into account by the camera's meter.
The gray areas illustrated on the matrix grid are "buffer zones" which the camera's fuzzy logic programming evaluates by analyzing the connecting sections.

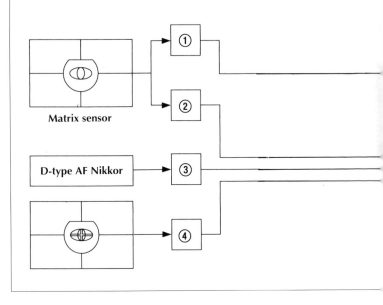

Matrix sensor

D-type AF Nikkor

changes ever so slightly or your subject moves into light shade, adjustments in exposure are made in minute increments. This occurs with any AF Nikkor lens.

Imagine a toddler roaming in a large area of dappled sunlight created by overhead branches and leaves. The brightness level fluctuates imperceptibly as you track the child's progress. Your color slides should offer consistent exposure from frame to frame, as fuzzy logic prevents any large/abrupt variations in exposure during continuous shooting. In a nutshell, this technology's methods of evaluation are more like the continuous human thought process.

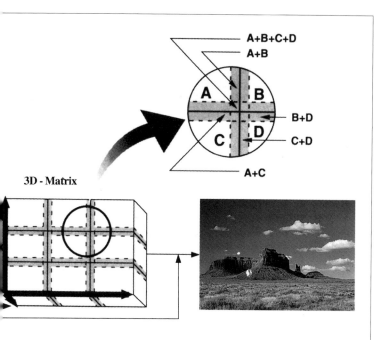

**3D - Matrix**

Not only does the 3D Matrix metering include distance information from the D-type lenses, it also takes information from the AF system into account. Included in the metering equation is the position of the subject or area of sharp focus in the matrix grid.

## Limitations of Matrix Metering

The Advanced Matrix system is highly successful even in back lighting and scenes with extremely bright or dark areas. It can even handle sunsets automatically, producing beautiful results without severe underexposure.

Of course, terms such as "back light" (shooting into the light) are relative. In extreme conditions, the contrast between subject and background can be excessive, or well beyond the recording ability of the film. In such cases, even the N70/F70 tends to produce underexposed subjects. Nikon literature suggests the use of flash to obtain a pleasing image.

Then, too, when the subject occupies only a small part of the frame and bright surroundings overwhelm it, any system can be fooled. A distant skier on a snow-covered hill or a conch fisherman against a whitewashed Caribbean building may be underexposed. With a dark scene, like a water buffalo against black rocks, some overexposure will result.

The above should create little concern if you're shooting color negative films. Their wide exposure latitude (leeway for error) will usually allow for acceptable prints to be made. Switch to slide film, however, and even a minor metering error will be noticeable. That's why Nikon includes Exposure Bracketing, other metering patterns and a full complement of overrides.

**Hint:** Nikon recommends that the Advanced Matrix metering system be allowed to work without overrides as the system is already compensating for unusual conditions. User-input exposure compensation may not produce the desired results because the outcome is not fully predictable. However, experience indicates that one can improve Matrix metering once how it works, and its limitations, are understood. When in doubt, take one shot without correction and then another one with the estimated Exposure Compensation (described later).

If you frequently use slide film, it's worth shooting some tests in extreme conditions such as through foliage into an evening sun, a few rocks in a pond with extreme reflections, mirrored surfaces and small subjects in front of dark and light backdrops.

Since our tests were conducted with a pre-production model, we cannot draw definitive conclusions on the success of the N70/F70's Matrix system. However, the system is based on that of the N90/F90, among the best of any camera we have ever tested. This is worth noting because that expensive model is used in Matrix metering mode by many professional photographers with great confidence.

## Center-Weighted Metering

Nikon has always offered the option of Center-Weighted metering. In this mode, the primary emphasis is placed on the central area of the frame, denoted by the large reference circle on the

The Center-Weighted metering system biases exposure for the subject within the larger circle etched on the viewing screen. The computer-generated simulation below provides a visual approximation of the areas of the image which receive the greatest (and least) metering emphasis.

viewing screen. In the N70/F70, this section (25% of the frame area) is heavily weighted during the camera's exposure calculations. The surrounding 75% is considered as well, but to a lesser extent. This strategy offers a bit of a safety function by preventing an exposure based solely on the central subject, which may be extremely bright or dark. Thus, the odds of acceptable exposure increase slightly.

This option is included because many photographers learned their skills with a similar metering system. They know when to deviate from the meter's reading: overexposing to keep snow bright or underexposing for a black Poodle, for example. Such overrides are indeed necessary, even with print film, and even more so than with intelligent Matrix metering where the computer compensates to some extent.

Frankly, this is not a point-and-shoot metering pattern. But if you're planning on taking a photography course, it's one you will use frequently. Most instructors still gear their courses to Center-Weighted meters, because these are still common in most cameras.

**Hint:** This method also allows for metering a specific area of the subject, such as a pile of gray rocks in a snow-covered meadow. Move in close to the rocks or zoom in until the desired area fills the large reference circle on the viewing screen. Lock the exposure with the AE-L button while you reframe to include the snow, and shoot. Focus can be controlled independently with Focus Lock (light pressure on the Shutter Release button).

## Spot Metering

Similar in concept to Center-Weighted metering, Spot metering is even more precise. Instead of reading the light pattern in the entire scene (with emphasis on a large, central area), the Spot meter ignores all but a tiny segment. The N70/F70's meter reads only the 3mm central area, denoted by the small reference circle etched on the viewing screen.

This allows for reading the reflectance in a single, small subject element, such as a face in a crowd. Exposure is optimized exclusively for that point. If its reflective properties are precisely mid-tone, the camera will reproduce it exactly as desired. If the metered area is lighter or darker, the exposure will be shifted accordingly. Hence, the selected area is critical to the overall exposure of the entire picture.

Spot metering calls for expert judgment of tonal values, discussed briefly in a previous section. It takes an experienced photographer to be able to make the right choice. Spot metering should, therefore, be reserved for the advanced shooter (or for experimentation). If not used properly, it will produce fewer correct results in other hands than the other two metering patterns.

Those who are fully-versed will take advantage of this metering mode in difficult situations. The surroundings can be extremely light or dark, but the metered point (a tanned face, on a bright beach, perhaps) will be perfectly exposed. Looking through a stone arch, the cityscape will not be overexposed in spite of the predominantly dark "frame".

**Try capturing the spirit and flavor of the places you visit rather than documenting them in their most literal form. The photographer used an unusual camera angle and controlled the depth of field using Aperture-Priority mode to lead the viewer up the stairs and into an exotic city.**

⇧

When you shoot can be as important as what you shoot. The final light of day has a warm tone and produces shadows which bring out subtle details and textures in your subject.

The sun moves quickly in the late afternoon, and the light can change dramatically in a matter of minutes. Be prepared to capture it by scouting locations ahead of time and bringing the necessary equipment, such as a tripod.

Practice composition by photographing simple, uncluttered subjects. ⇨ This photo illustrates the classic "rule-of-thirds," which instructs the photographer to imagine lines dividing the image in the viewfinder into thirds vertically and horizontally. Important elements in the photograph, such as a horizon line or the doorknob in this picture, are then positioned on one of these imaginary lines. Notice the hanging cloth also follows these proportions.

Choose a long focal length lens if you want to stand back from your subject and remain fairly inconspicuous. (upper left) Or use it to take more intimate portraits without getting too close. (upper right) The longer focal length in combination with a large aperture was also excellent for reducing the distracting background to a soft blur of green.

(bottom left) The shop was cramped and the photographer didn't have much room to maneuver. Instead he used a short focal length lens. The lens' wide angle of view allowed the picture to include the man, the boy and a portion of their shop.

A zoom lens (above) was used to selectively frame and compose the girls in the window and crop unwanted items from the picture. A telephoto lens (right) was used at a fairly close distance for this photo. Notice how shallow the depth of field is with the long lens and large aperture. Precise focus is important when depth of field is so limited. Generally, photographers choose the eyes as the point of focus for portraits like this one. Viewers are drawn to a subject's eyes and expect them to be sharp.

*Note:* Spot metering usually requires use of the AE-L key unless you're shooting in Manual mode. The specific detail to be metered is very rarely dead center in the final composition. Locking the Spot exposure reading (and then recomposing) is essential, even more so than with other metering patterns.

## Autoexposure Lock (AE-L)

As mentioned earlier, the N70/F70 locks and holds focus while you maintain contact on the shutter release. However, the exposure reading is not locked! Try panning the camera from side to side and note the exposure data changing. They're corresponding to the brightness level of the current image: a bright sky first, then the black asphalt pavement and then the grass and trees.

In many situations, this is exactly how it should be. After all, you frequently want the exposure to match the ultimate composition, such as in a landscape or travel scene. In other cases, as with a deep-sea fisherman, you may decide that the opposite would be more effective. Locking the exposure reading on the subject and then recomposing to include the ultra-bright ocean may well produce the preferred effect. With the N70/F70, exposure can be locked on the preferred area while you recompose in any of the Automatic or Program modes. This requires pressure on the AE-L (AE Lock) button.

## Exposure Metering Reviewed

Most in-camera meters are calibrated to render the metered area as 18% gray. Brighter areas in the scene will be rendered as brighter in the final image. Darker areas will be rendered darker. This is ideal unless you take the reading from a light area (perhaps a sandy white beach) or a dark area (perhaps a dark-blue boat in shade).

◁ **A vender's cart in an alleyway shows off the play of light and shadow caused by sidelighting. Use Matrix metering or try Spot metering, perhaps on the area in shadow under the blue sign.**

In the first case, the beach will be rendered as a mid-tone, or medium gray. Your friends under a palm tree will be rendered as much darker (underexposed), probably without detail. In the second case, the boat will be rendered as medium-blue. The boat's white sails will be overexposed, appearing washed out and without detail. Advanced Matrix metering will compensate to some extent, producing better results (in fairly bright sand or snow, for example). And your photofinisher may make some adjustments, producing an acceptable print. Such adjustments cannot be made in slide processing, however.

There is another useful technique you may want to try, called substitute metering. This involves taking the exposure reading from something which is a mid-tone, even if it will not be included in the final composition. Take the meter reading from the gray paving stones on a chalet patio, and lock it in with AE-L. Then swing the lens back toward the skiers coming down the slope and take the picture. If both are in similar light, the final print should be nicely exposed. The exposure is calculated for the mid-toned patio stones, instead of the snow which is usually some 2 stops brighter than mid-tone.

**Hint:** If there isn't an 18% gray object in the scene, a Kodak® Gray Card is a standard substitute. You can buy one at any photo store and use it as a metering target, recomposing with AE-Lock. Or meter off grass, foliage, a mid-toned tree trunk, a tanned face, etc., instead. The color need not be gray but the tone must approximate 18%, and the light falling on it must be the same as the final subject.

**Exposure Control**

Entire books have been written on exposure metering and they are worth reading, especially if you shoot slide film. A treatise on the topic is beyond the scope of this guide, so we can offer only a few brief hints here. These guidelines will help to produce better exposures than the strictly automatic approach.

1. In Matrix metering, the N70/F70 will produce good exposures in the majority of situations. However, as mentioned earlier, it will tend to expose incorrectly when the subject is surrounded by an ultra-bright or a very dark area. Use flash if possible, or try one of the other tips in such conditions.

2. With any of the three metering patterns, good results are produced when you take the meter reading from an area you that will be reproduced as a mid-tone in the final image. Trees, grass, buildings, etc. often make for suitable substitute metering targets. Use AE-Lock when recomposing to include its surroundings.

3. Many situations found in nature average out to a mid-tone. A bit of bright sky, foliage and darker foreground rocks make for an ideal combination. With such situations, even an unsophisticated light meter will produce accurate exposure.

4. Try to exclude large expanses of bright sky (or a snowy hill, or very dark mountainside) when first composing. Point the lens toward a mid-tone and lock exposure with the AE-Lock while recomposing and taking the picture. This will guarantee a more accurate exposure with any of the three metering patterns.

5. When a large subject fills much of the frame, you'll need to consider its reflectance. Unless it is extremely light-toned (a white Cadillac, perhaps) or dark-toned (a black Porsche) it will produce a satisfactory exposure. In a later section, we will provide some hints on specific methods of metering, but the AE-Lock button will be an important component.

6. In Autoexposure modes, exposure compensation can be dialed in to overexpose the white Caddy to render it white instead of gray, or to underexpose the black Porsche to render it black instead of gray (also refer to the section on manual exposure control).

7. The Matrix system of the N70/F70 will input some automatic compensation of its own, especially in ultra-bright conditions. This reduces the risk of underexposure since the system attempts to render snow as white (for example) instead of gray. When shooting with "forgiving" color print film in Advanced Matrix metering, you rarely need to worry about exposure or the need for compensation.

# Automatic Exposure Modes

The N70/F70 features a complete range of exposure modes from program to fully manual. In combination with the three metering patterns, the various exposure modes make the N70/F70 an extremely versatile camera. In this chapter, we will go beyond the instruction manual for an in-depth discussion of the use of each mode in real-world photography.

## Multi Program Mode (P)

This is the "point-and-shoot" mode. The N70/F70 automatically selects the best combination of aperture (f/stop) and shutter speed. These may not be ideal to depict motion or depth of field exactly as you expect, but the results will be acceptable for quick shooting.

Nikon includes the term "Multi" because the selected combinations depend upon the focal length of the lens. With telephotos, the Program favors high shutter speeds (such as 1/500 second) to try to prevent blur due to camera shake. With wide-angle lenses (such as 28mm) it favors smaller apertures (such as f/11) for more depth of field. The shutter speed will be longer, of course, but short lenses do not require high speeds for handholding the camera.

*Note:* As the brightness level increases, the Program combines smaller apertures with faster shutter speeds. When the light level drops, it selects wider apertures to maintain shutter speeds which will provide sharp pictures when the camera is handheld. Eventually, in low light, this will not be possible and the flash symbol will blink. In this case, activate flash if you want a sharp picture.

As we have discussed previously, a higher shutter speed calls for a wider aperture for correct exposure. Consequently, depth of field is reduced. A smaller aperture calls for a longer shutter speed, not ideal for freezing motion. Such compromises are a fact of life in photography. However, when you allow the Program to set both

In unusual shooting situations, the Multi Program mode and Matrix metering can make your life easier. Maybe your subject isn't going to stick around while you play with the camera controls. First take the photo, letting the camera choose exposure; then if you don't want to take the camera's "advice," change the settings using your own judgement.

variables, you have no control whatsoever. Consequently, the depiction of motion and depth of field may be totally inappropriate for the situation.

## Flexible Program Mode (P*)

Program mode becomes more flexible through the use of so-called program shifts. Turn the Control dial when you are in P mode and the aperture/shutter speed combination is changed. Turn in one direction and wider apertures with faster shutter speeds are provided. Turn in the other, and smaller apertures and longer shutter speeds are automatically selected. Hence, the same amount of light is always exposing the film for equivalent exposure in any combination (remember our swimming pool analogy in an earlier section on exposure).

You can therefore shift the settings toward greater depth of field for a wide range of apparent sharpness. Or shift toward shallow depth of field to blur out a distracting background. By the same token, you can shift until reaching a long shutter speed which will blur the waterfalls into a soft flow. Or shift to higher speeds to freeze a ski jumper in mid air without blur.

The "shifted" values are maintained as long as the metering systems remain active; that is, while you maintain contact with the trigger. Remove your finger, however, and the metering systems shut down after eight seconds. Now the shifted aperture/shutter speed values are deleted. The N70/F70 reverts back to its own system-selected settings. This can be annoying or frustrating, but it is common in all cameras.

*Note:* Unlike most Nikon cameras, Program shift is in 1/3 stop increments. As you shift, watch the displays. You'll notice that the shutter speed changes in 1/3 steps: 1/125 second, to 1/160 second, to 1/200 second, to 1/250 second, to 1/320 second and so on. The f/stop display changes only in full stops: f/5.6, to f/8 to f/11, and so on.

However, the aperture shift is also being calculated in small increments. The display shows the closest full f/stop but the system can select any required aperture to correspond with the shutter speed: f/6.2, f/7.8, f/8.4 or whatever is suitable.

## Aperture-Priority "A" Mode

This is probably the most frequently used form of semi-automatic control, referred to as Aperture-Priority mode. Here you have full control over the aperture, while the N70/F70 responds with a suitable shutter speed to maintain equivalent exposure. When you control aperture size (with f/stops) you're primarily interested in depth of field control. But indirectly you control the shutter speed, as well, as previously explained.

Select f/16 for a landscape with an extensive range of sharpness and the system might set 1/60 second on a brilliant day at ISO 100. Stop down to a wide f/5.6 and you get 1/500 second. Depth of field is limited now, but the wind-induced motion of the grasses is also frozen.

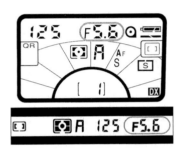

**In the Aperture Priority (A) mode, f/stops are selected by the photographer using the aperture ring on the lens. The camera then automatically sets a corresponding shutter speed for correct exposure.**

You select the desired f/stop on the lens' aperture ring in this mode. You can select full stops or set the ring between two numbers for 1/2 stops. The display shows the nearest full stop number. This allows you to experiment freely. The chosen aperture is maintained as long as you want, unlike in Program shift. The camera never reverts to its own choice of f/stop.

Turn the aperture ring as you watch the viewfinder displays, stopping when you hit a combination which seems most appropriate for the situation. If clouds drift over the sun, f/16 might produce a 1/15 second exposure. That's too long for hand-holding the camera. So compromise a bit of depth of field by switching to f/8 in order to maintain a 1/60 second shutter speed.

Aperture-Priority mode is perfect whenever exact depth of field is important. This could include nature, close-ups, portraits or candids in cluttered surroundings. As lighting changes, the system

automatically varies the shutter speed to maintain equivalent exposure.

*Note:* When using manual focus Nikkor lenses, Aperture-Priority and Manual are the only exposure mode choices as the Program modes will not function.

With any lens, this can be considered a universal program mode. Once you have fully grasped the relationship between aperture and shutter speed, you'll frequently switch to "A" mode.

*Note:* The "HI" and "LO" displays warn if there is a danger of over- or underexposure in extremely bright or dark conditions. Switch to a smaller or wider aperture until the symbol disappears.

## Shutter-Priority "S" Mode

In Shutter-Priority mode you select the exposure time from 1/4000 second to 30 seconds in 1/3 step increments. The camera automatically sets an appropriate aperture displaying an f/stop number. Again, the system can select from thousands of intermediate aperture sizes (such as f/8.6 or f/17.9) but the nearest full stop is displayed along with the shutter speed.

*Note:* Lock the aperture ring on the largest f/number.

Once selected, the shutter speed remains constant with only the aperture size varying as the lighting changes. Hence, you have full continuous control over the rendition of motion. This could

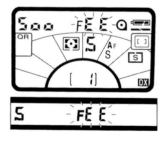

In Shutter-Priority (S) mode, the lens' aperture ring must be set to the highest f/number. Otherwise the error message "FEE" is displayed on the LCD panel on the body and in the viewfinder.

be blurred, partially blurred or frozen in time. There's no computer to second-guess your intentions. But do monitor the system selected f/stop in the display.

As you select faster shutter speeds, the system will respond with wider apertures, reducing depth of field. As you shift to long shutter speeds, it will offer smaller apertures, thus increasing the range of apparent sharpness. As explained previously, the two functions are not independent of each other. Shift one and the other will be system shifted, too, in order to maintain an equivalent exposure.

**Hint:** Although Shutter-Priority is often used in action photography, freezing motion is not always desirable. At a motorcycle race, for example, try "panning" at longer shutter speeds. Select 1/125 second, for example, and aim at a Yamaha traveling in front of your position. Follow it smoothly with the lens, moving your upper body to do so, pressing the shutter release in the middle of the pan, for one or more exposures.

Experience indicates that following through after the pictures have been taken produces the smoothest results. Your subject will be relatively sharp against a blurred background for a convincing impression of motion. The ideal shutter speed depends on a variety of factors: focal length, subject distance, subject velocity, angle of approach, etc. Experiment with a variety of shutter speeds until you determine the one which seems most effective for your next outing.

*Note:* The "HI" and "LO" exposure warning symbols may again appear in extremely bright or dark conditions. Switch to a longer or shorter shutter speed until the symbol disappears.

## Manual Mode (M)

If you want to take over full control of aperture and shutter speed, switch to Manual mode. Now you have total control over exposure and can ignore the meter's recommendations when desired. Before trying this in actual shooting, however, practice with an expendable roll of film.

*Note:* In Manual mode, the N70/F70 does *not* automatically set either the f/stop or shutter speed for correct exposure. Watch the

| | | |
|---|---|---|
| **+ı..0..ı—** ◀❙❙❙❙ | **+ı..0..ı—** ❙❙❙❙ | **+ı..0..ı—** ❙❙ |
| Over +1 stop | +1 stop | +1/3 stop |
| **+ı..0..ı—** ❙ | **+ı..0..ı—** ❙❙❙ | **+ı..0..ı—** ❙❙❙❙▶ |
| Correct exposure | -2/3 stop | Under -1 stop |

**In Manual mode (M), the analog scale in the viewfinder provides exposure guidance, denoting the deviation (from +1 to -1 stop) from the meter recommended value.**

analog scale in the viewfinder for warnings of over- or underexposure with any combination selected.

Again, shutter speeds are selected in 1/3-stop increments with the Control dial and f/stops (in full or half stops) with the lens' aperture ring. The analog display in the viewfinder serves as a guide for comparing what you have set to what the camera considers the "correct" exposure setting. The central point on the scale denotes "correct" exposure, according to the camera's meter. It displays the deviation in 1/3 EV (stops) for over- or underexposure. An arrow at either end indicates a deviation that exceeds the range of the display scale.

Because of the N70/F70's 1/3 step shutter speed increments, subtle exposure modifications are best made by varying this factor. Perhaps you want slight overexposure from the metered value for light skin tones. As a starting point, set a combination which shows +1-1/3 stop (overexposure) according to the meter. Instead of being rendered as too dark by underexposure, the face will be reproduced lighter and closer to its natural appearance.

***Note:*** Any of the three different metering patterns can be selected in Manual mode. Since this is an advanced camera operating mode, you may not want to select Matrix; it provides less predictable results due to system-imposed compensation factors. We

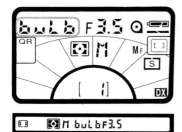

In Manual mode (M), the longest timed shutter speed is 30 seconds. For longer exposures, use the "bulb" setting which holds the shutter open as long as the shutter release button is depressed. No metering guidance is provided, but the f/stop is displayed.

recommend Spot or Center-Weighted metering for photographers with the experience to routinely shoot in Manual mode.

Manual control has no advantages over the camera's automatic modes if you just expose according to the meter's recommendations. As soon as you want to achieve special results that require a deviation, Manual mode becomes useful. There's no longer any need to use the AE-Lock key as exposure does not change when you recompose (ignore the analog scale warning of incorrect exposure while recomposing after taking a meter reading from a desired area). There's also no need to dial in Exposure Compensation because you can over- or underexpose at will.

**Hint:** During practice with Manual mode, start with an aperture and shutter speed combination that sets the pointer at the center of the analog scale. From there, you can fine tune the exposure by changing the aperture, the shutter speed, or both. Experience may indicate that a scene with a bit of snow (or a sandy beach) may call for a +2/3 stop overexposure for a bright look. Turn the Control dial or the aperture ring and watch the scale until the arrow reaches +2/3.

With a dark red sports car, you may decide that a 1-1/3 stop underexposure (from the meter's suggestion) may be best to render the subject richly-saturated. Change the f/stop or shutter speed (or both) until the arrow denotes a -1-1/3 stop deviation from the meter's recommendation. You may recall that the Center-Weighted and Spot meters are calibrated to reproduce the metered subject as a mid-tone. That will be medium gray for snow and medium red for the sports car in the above examples, unless you exert personal control as mentioned above.

*Note:* Exposure Compensation can be used to achieve exactly the same results in Program or Auto modes, too. However, this is more time consuming to set and may then need to be changed for the next picture. The Manual approach is more useful when the amount of over- or underexposure will differ for each photo. *But take care not to begin shooting quickly as if the N70/F70 were in an auto mode, to prevent incorrectly-exposed pictures.*

## The "Correct" Exposure

Except in Manual mode or extreme situations, you will often rely on the Matrix metering system of the N70/F70 because it is so reliable in producing (or suggesting) correct exposure. We again recommend that you shoot a few rolls of slide film in a broad variety of conditions to become familiar with the results Matrix produces in each type.

We have already mentioned that exposure overrides are not officially recommended with Matrix metering. If you experimented with its performance as described, however, you may decide to ignore Nikon's recommendation. Overexpose a snowy scene by one stop or underexpose a dark log cabin by one stop for the best results, even with this intelligent metering system (with the Center-Weighted pattern +2 and -1-2/3 stops of compensation might be needed for the two examples above).

Exposure override (+ or -) is primarily used for Center-Weighted metering, as previously described. After gaining some experience in judging tonal values, you will know when a scene requires over- or underexposure.

**Hint:** If you're still confused, memorize this: A bright subject needs + exposure compensation to render it bright. A dark subject needs - compensation to render it dark.

Aside from producing photos with "correct" exposure, you may decide to become more creative. To create mood or atmosphere, you might prefer intentionally dark slides on a stormy day or very bright slides for a stream shrouded in mist. These may not be the most technically "correct" exposures but they will best communicate your impressions of the subjects on film.

**An exposure compensation factor of +/- 5 stops, in 1/3 stop increments, can be set with the N70/F70.**

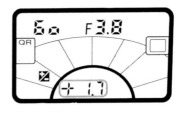

*Note:* We do not recommend routine underexposure of color print film beyond that required for a correct rendition of the subject. Negative films lose color saturation and exhibit increased grain with underexposure.

**Exposure Compensation Function**

In Auto and Program modes, you will dial in some "+" or "-" compensation to achieve desired effects. Use the Function and SET keys plus the Control dial to set the desired level of compensation (in Manual mode, exposure is controlled by setting the desired f/stop and shutter speed instead).

The N70/F70 gives you plenty of room for an exposure correction: a full five exposure values (EV) up and down in 1/3 stop increments. Frankly, it is rarely necessary to compensate by more than 2 EV in any situation.

*Note:* One exposure value (EV) corresponds to one aperture or shutter speed increment or a combination of both totaling one stop. This term is frequently used in published material, so you should be aware of its meaning. Think of one EV as one stop, two EV as two stops, etc.

Naturally, "+" stands for more exposure (a brighter rendition) while "-" denotes less exposure (a darker rendition). A "+/-" symbol in the viewfinder and the LCD panel reminds you that some compensation factor is in effect. *This remains active until it is reset to zero!* Even turning the camera off doesn't delete this. To avoid incorrect exposures in the future, remember to cancel Exposure Compensation as soon as it is no longer required. If you switch to a Vari-Program however, the compensation factor is no longer in effect.

**Automatic Exposure Bracketing (BKT)**

Every now and again, you'll encounter a subject which may require some exposure override, however, you're not certain how much would be best. Particularly with slide film, slight exposure compensation from one frame to the next will produce very different effects. In order to bring out the best nuances in the subject, you may decide to shoot several frames, varying the amount of exposure override for each one.

This can be done in one of three different ways: First, by shooting in Manual mode for full exposure control of each frame. Second, by dialing in different amounts of compensation for each frame, one at a time: +1/3 for the first, -1/3 for the next, and so on. This can be time consuming, so Nikon offers a third alternative with the N70/F70 called Auto Bracketing.

Set BKT in 1/3, 1/2, 2/3 or full EV steps as desired. We find 1/3 EV increments most useful with slide film and 1 EV best with color print film. Select the desired factor by pressing the SET button and turning the Control dial until the desired selection appears in the AEB section of the LCD panel.

In single frame film advance (S), the first shot will be underexposed by the selected factor, the second according to the metered value, and the third with the corresponding overexposure. You need to depress the shutter release for each shot. If you want the entire series fired quickly, switch to continuous film advance (L or H). The camera stops firing automatically after the three shots.

**Note:** After the sequence has been completed, the BKT function is deactivated automatically. To shoot another bracketed series, simply press the Function key and then the SET key. Turning the camera off erases the Auto Exposure Bracketing settings.

In Program mode, both aperture and shutter speed are changed for the required exposure compensation from one frame to the next. In Shutter-Priority automatic, only the aperture is shifted. In Aperture-Priority automatic and Manual mode, the N70/F70 changes the shutter speed. Watch the latter before starting the sequence. The exposure time may become too long to handhold the camera, resulting in unsharp picture.

Three photos in a series illustrating the Auto Bracketing feature. The photo on the far left is underexposed by 1/2 stop, the center photo is exposed at the meter's correct setting, and the near left photo is overexposed by 1/2 stop.

# Subject-Specific Vari-Programs (Ps)

Turning the Control Dial while pressing the "Ps" key takes you into the subject-specific programs that Nikon calls "Vari-Programs." Customized for specific situations, these make it easier to get good results in eight diverse categories. An optimum shutter speed or aperture is selected automatically and maintained even as the brightness level changes.

The lens' aperture ring must be locked in at the largest f/number as with program modes. An arrow under the row of pictograms at the top edge of the LCD moves from left to right or the other way around depending on which way you turn the Control dial. The subject-specific programs are all called "Ps" in the display panel. The shutter speed and aperture are always visible in the viewfinder so that you can estimate the likely effect (on depth of field at f/5.6 vs. f/16, for example).

The N70/F70 offers eight customized programs. These generally will better suit a portrait, sports subject, landscape, etc. than the "all-purpose" Auto-Multi Program. They're especially useful when someone not familiar with the camera will be using your N70/F70 or whenever you must shoot quickly and will not have time to set a specific aperture or shutter speed.

*Note:* You can, of course, produce the same results by making your own settings in one of the other modes discussed. The Vari-Programs are therefore not essential but are included for greater convenience.

### Portrait Program

The experienced portrait photographer will often select a focal length from 85mm to 135mm for portraits, sometimes moving up to 200mm or 300mm to isolate the subject from the background. The Portrait Program operates on this assumption. Using it with shorter focal lengths would rarely make sense as depth of field would be excessive.

The Portrait program routinely opens the lens to the widest aperture possible, depending on lighting conditions, lens and film speed in use. With telephoto lenses especially, this results in shallow depth of field. The subject will usually be rendered as distinct, in front of a softly blurred background, unless the latter is

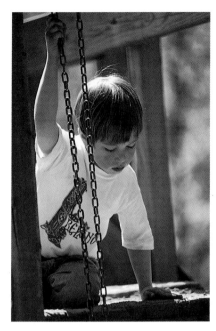

**Choose Portrait Program any time you don't want the background to be obvious and distracting.**

quite close; within the range of sharp focus. The exposure is controlled with the shutter speed alone and will generally be longer in dim light and shorter in bright conditions.

**Hint:** Let's say you're using the exceptional AF 80-200mm f/2.8 D ED Nikkor zoom set at 200mm. The Program will select f/2.8 on bright days for shallow depth of field. In a tight close-up this may not keep the entire subject in sharp focus; the ears may be slightly blurred. In any portrait, focus for the nearest eye with both humans and animals. Even if everything else is unsharp, the picture will have impact.

In principle, you can select this Vari-Program whenever you want minimal depth of field, regardless of what the actual subject is. You may decide to use flash with this subject program: either the built-in Speedlight or an accessory unit. The N70/F70 will select a shutter speed between 1/125 and 1/60 second. This is ideal outdoors in order to brighten shadows by using automatic Multi-Sensor Balanced Fill Flash. (Combining this Vari-Program with the red-eye reduction function is also possible). However, these shutter speeds may require smaller apertures in some cases, increasing depth of field beyond the desired level.

## Depth of Field Program

This Vari-Program is depicted by a pictogram of two people with mountains in the background. Called the Hyperfocal Program by Nikon, it is designed to provide extensive depth of field in order to render both the foreground and background of the photograph acceptably sharp. This program is well-suited for group shots where extensive depth of field is required so that everyone in the picture appears in focus.

How well this succeeds is, of course, dependent on the lighting conditions. In low light, small apertures such as f/16 would not be practical because the resulting long shutter speed would cause subject blur or camera shake. The camera generally selects f/8, with smaller apertures only in extremely bright light. Larger apertures are never selected.

**Note:** Pay close attention to the shutter speed display. Occasionally, you may need to use a tripod to avoid camera shake should the shutter speed fall below the suggested guidelines (1/60 second with a 50mm lens, 1/250 second at 200mm, and so on).

## Landscape Program

When designing the Landscape Program, Nikon appears to have made some logical (but not necessarily certain) assumptions. The first premise is that there will be some sky in a landscape. Consequently, the Matrix metering system compensates to prevent underexposure of the foreground.

The second premise is that, when possible, everything should be rendered in sharp focus, from foreground to background. Nikon recommends the use of wide angle lenses, whose depth of field is quite extensive at any aperture. The N70/F70 often selects f/8 much like the Hyperfocal Program. However, the focal length of the lens is considered in the equation; with a 20mm lens, f/16 is commonly selected. With a 50mm lens, f/8 is more likely. Hence, shutter speeds are usually maintained for handheld photography

If you plan to isolate small components of a vast landscape with a telephoto lens, this program is not the right choice. After all, you need faster shutter speeds to handhold the camera. Or you may want smaller apertures (like f/22) for more depth of field while using a tripod.

Choose a focal length slightly shorter than 50mm to maximize the benefits of the Lanscape Program.

**Hint:** Even with a wide-angle lens, some landscapes call for wide apertures such as f/2.8 to blur foreground leaves for artistic effect, perhaps. Or you may want f/22 to render them sharply instead of the f/11 selected by the Landscape Program. Frankly, specific effects are better achieved with Aperture-Priority automatic mode instead. But for quick shooting from the roadside while your family is waiting impatiently, this Vari-Program will provide acceptable landscape pictures.

### Close-Up Program

Denoted by a pictogram of a flower, this Vari-Program is likely to be used for nature close-ups. Most N70/F70 owners will have a zoom lens such as the AF 35-80 f/4-5.6 D or one with longer focal lengths. Those with a "Macro" designation can focus quite close so you can move in to record a large blossom or a model airplane without accessories.

The Close-Up Program assumes you will be shooting in this manner. Because depth of field will be quite shallow for such subjects, the system selects f/5.6 or f/8 for a limited range of sharpness in close-focus work. The entire subject should be within the depth of field but the background will be softly rendered to prevent distractions.

This Vari-Program can be successfully combined with automatic Fill Flash so that shadows can be lightened. The "aperture calculation" changes slightly as a result because the shutter speed is fixed at 1/125s. Smaller or wider apertures may be required to produce correct exposure with flash.

*Note:* If shooting with lenses of even higher magnification, such as the Micro Nikkors, depth of field is extremely shallow, requiring f/16 or f/22 to render a three-dimensional subject sharply. Switching to Aperture-Priority automatic is a much more valid technique. However, for quick snaps of small objects with acceptable results, the Close-Up Program is often useful with macro zoom lenses.

### Sports Program

Although Nikon calls it the Sports Program (denoted by a runner), this seems rather limiting. Action Program would be a better term, since this Vari-Program is useful whenever high shutter speeds are required to freeze fast motion. In this program, the N70/F70 is biased toward high shutter speeds that are at least 1/1000 second depending on the lens and brightness level of the scene.

Aside from freezing motion, depth of field is shallow, as fast shutter speeds call for wide apertures. Hence, the main subject is sharply rendered against an out-of-focus background, often desirable in action photography.

*Note:* On overcast days, an ISO 400 film may be required for fast shutter speeds. This more sensitive film requires less light for correct exposure, allowing for speeds of 1/1000 second in most cases, with lenses of f/5.6 or wider maximum aperture.

Children or pets tearing around, a soap box derby or any action situation is well rendered by the Sports Program. Use telephoto

**If you want the N70/F70 to bias exposure for a fast shutter speed, either for a fast subject or for handholding a long lens, use the Sports Program.**

lenses of 200mm and longer for the most pleasing results. The shallow depth of field and the isolation of the primary subject are both image enhancing factors. Because backgrounds are often cluttered (by other spectators for instance) a 300mm lens works well for many action subjects.

**Hint:** Avoid using flash. The 1/125 second shutter speed may call for smaller apertures than are desirable. Besides, your subject will often be out of range of all but the most powerful Speedlights. Continuous AF (with Wide-Area detection) and high speed film advance are well-suited to continuous shooting in sports or action photography.

## Silhouette Program

This is a very specialized Vari-Program unique to Nikon. Denoted by a palm tree at sunset, this program is easily misunderstood. It is intended only for situations where there is a dominant subject in front of a much brighter background. A lighthouse, standing on weather-worn rocks at sunset is but one suitable subject. The silhouette program creates intentional underexposure of the darker area, metering only for the highlights.

We would not recommend this Vari-Program for standard sunsets on land or water. The conventional Matrix metering (in any other mode) produces better results. It is really only useful in situations defined above. Needless to say, Silhouette Program is definitely not suitable for use with flash as the entire purpose would be defeated.

**Caution:** Never look at the sun with the naked eye or through a camera/lens. Damage to the retina may occur, causing permanent loss of sight.

## Night Scene Program

Few amateur photographers seem to shoot at night in spite of the additional opportunities it presents. If you fall into this category, try going out one evening at twilight or later with the N70/F70 and a tripod. Portraits in front of city lights are just one common subject which can produce appealing results with correct technique.

Nikon makes this easy with Night Scene Program, with or without flash. Slow shutter speeds are selected, thus, a tripod is essential. Mid-sized apertures (such as f/8) are automatically set for good depth of field.

**Hint:** In our experience, this Vari-Program is ideal with flash. The long exposures allow the darker background to register on film, while the burst of light illuminates the subject (perhaps a friend sitting on a balcony with a skyline in the background). Instead of the usual black void, the backdrop is nicely exposed, increasing the atmosphere significantly. Even with flash, the long exposure times require a tripod unless you intentionally want subject blur for creative purposes.

The Night Scene Program chooses a slow shutter speed and small aperture combination for exposure in low-light situations. The small aperture provides ample depth of field; notice the entire length of the train is in focus.

## Motion Effect Program

This Vari-Program's objective is praiseworthy because the depiction of motion through a degree of blur is fascinating. With the proper technique, it produces far more dynamic photos than those which are "tack sharp." Blurred motion has an appeal of its own, particularly as it evokes a sense of motion in a still image.

We have previously described the "panning" technique using longer shutter speeds (like 1/30 second to 1/125 second) for a greater impression of motion. This is rarely possible with the Sports Program, so Nikon designed the Motion Effect Program. Cyclists, athletes, cascading waterfalls, and other movement will produce

pleasing motion blur when longer shutter speed are selected. Water droplets take on their familiar form instead of being frozen in mid-air.

This Program selects 1/60 second quite often with ISO 100 film in bright conditions. That's appropriate for high speed subjects but often too fast for slower action or flowing water, for instance. We prefer Shutter-Priority automatic at 1/15 second with waterfalls or joggers. Nonetheless, the Motion Effect Program is more likely to be used in sports as suggested by the pictogram of a runner with motion streaks.

**Hint:** Keep an eye on the shutter speed. It is often too long for casual handheld pictures. Do not use fast ISO 400 film on bright days or the shutter speed (often 1/250 second) will be too fast for motion blur.

### The Vari-Programs Evaluated

These customized programs are fine for casual photography or for anyone wanting to experiment with a variety of effects. The primary drawback is that they are restricted by the lens in use. The Sports Program, for instance, is best when used with a lens with an f/2.8 maximum aperture. However, many photographers shoot with zooms of f/5.6 at longer focal lengths, making shallow depth of field or high shutter speeds impossible.

With such "slow" lenses, do not expect a great deal of difference from one Vari-Program to another. Using more sensitive films, such as ISO 200, provides more latitude in some programs at least (to shorter exposure times and more depth of field). Moving to slower films (such as ISO 25 or 50) can produce longer exposure times and wider apertures for less depth of field. But anyone who routinely switches film types is unlikely to want (or need) these computerized programs.

**Hint:** If you like the concept of customized programs, do not restrict their use to the obvious. The following concepts are but a few which should be kept in mind when deciding which Vari-Program to select.

| Desired Effect | | Vari-Program |
|---|---|---|
| For shallow depth of field | use | Portrait |
| For frozen motion | use | Sport |
| For long exposures with flash | use | Night Scene anytime |
| For group shots | use | Hyperfocal |

## Memory Function (QR)

The N70/F70 breaks new ground by memorizing up to three combinations of control settings for quick recall. This function also makes returning to factory default settings (0) quick and easy, at the touch of a button.

The Quick Recall (QR) function requires some explaining. Let's start with the basic setting (0). To call it up, make sure the camera is on, then press the OUT key and turn the Control dial counter clockwise past the numerals 1, 2 and 3. A "0" then appears in the yellow QR segment. Release the OUT key, and the camera is reset to factory-programmed settings: single frame film advance (S), Wide-Area focus detection, Single Shot AF (S), Advanced Matrix metering, Program mode (P), normal flash sync with zero exposure correction, no AE Bracketing, Exposure Compensation or flash bracketing.

Numerals 1, 2 and 3 are for your own use. Here, you can set any combination you like; three sets of combinations, in fact. After you have the N70/F70 set up exactly as you want, press the IN button and turn the Control dial counter-clockwise until #1 appears. As soon as you let go of the key, the setting is stored at that number. Should another setting be later stored at this number, it will override earlier settings automatically. If you want two extra sets of settings stored, do so in #2 or #3 using the procedure outlined above.

Since the combination of settings includes autofocus, QR only works if the lever is at "AF". If you turn the camera off and then on again, you will notice that the last QR number reappears, along with its settings. To return to full control, modify any of the settings: film transport mode, AF detection area, metering mode, exposure mode, flash synchronization or exposure correction.

This clears the QR panel and you are back to where you were. You do have to allow some time for the camera to "understand"

the change. If you only use the change for a short time and then return to the original, the QR number reappears as well. This may sound confusing but try it a few times until it seems simple.

## The Self-Timer

To set the self-timer, simply press the SET key (which bears the self-timer symbol). As soon as you turn the Control dial (while holding the SET key) one click to the left or right, the symbol stays on. The self-timer has been set.

If you end up in this setting by mistake, turn the Control dial another click (while holding the SET key). The symbol disappears.

When the shutter release is fully depressed, little arrows start flashing in all function areas. The LED under the shutter release in the grip flashes for eight seconds. Then it stays on to tell you that the exposure is imminent. After this 10 second delay, the shutter opens to take the picture.

The fact that the camera has to be placed on something solid for a self-timer exposure should be obvious. Avoid standing in front of the lens when pressing the trigger or you'll confuse the AF and metering systems.

*Note:* Stray light entering though the viewfinder can affect exposure metering when the eyepiece is not up against the eye. Nikon, therefore, supplies an eyepiece cover DK-5 with the camera. Or simply cover the eyepiece with your hand when pressing the shutter release. From this point on, exposure is locked.

If you change your mind while the self-timer is counting down, simply turn the camera off. After a self-timed exposure, the N70/F70 returns to normal operation. You have to repeat the procedure for a second self-timed exposure.

The self-timer has another useful function: tripping the shutter without jarring the camera when mounted on a tripod. The N70/F70 does accept an electronic remote control cable but it is a bit expensive. Let the self-timer trigger the camera whenever desired. During the 10 second interval, all vibration will dissipate.

**Hint:** When using the self-timer to include yourself in the picture, try to add some life to the shot. Don't all stare intently at the

**Use the camera's self-timer to include yourself in vacation photos.**
**Photo: Paul Comon**

camera as if you are expecting the famous "birdie" to appear. Talk to each other, act as if you are "extras" in a movie, do something (other than staring into the camera!) In short, don't make self-timed exposures monotonous.

# Flash Photography with the N70/F70

The N70/F70 is particularly versatile when combined with flash, whether it is the built-in Speedlight or an accessory Nikon system flash unit. Its exclusive 3D Multi-Sensor Balanced Fill Flash feature ensures correct exposure of the main subject even in difficult scenes. In this chapter we'll review the various features and provide some hints on getting better pictures with an extra burst of light.

The N70/F70 automatically provides proper exposure for subjects within range of the Speedlight in use. Flash output is controlled by the five-segment TTL Multi Sensor. The term TTL denotes "through the lens" flash meter readings. The camera contains a separate metering cell which reads light reflected off the film when the shutter opens. As soon as sufficient exposure has been received, the system turns the flash off.

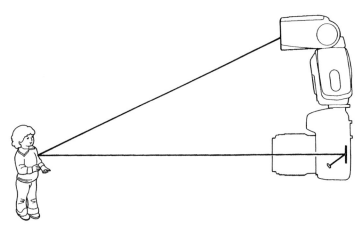

With TTL flash metering, the exposure reading is made through the lens for the greatest overall accuracy. The light is directed to a five-segment TTL Multi Sensor. With suitable Speedlights, a series of pre-flashes are fired before the exposure, to test the scene for the greatest exposure accuracy.

Even when a dense filter (such as a polarizer) or other accessory is used on the lens, the TTL reading remains accurate. In typical conditions, an aperture or shutter speed can be selected (within limits) or the camera can simply be used in fully automatic Program mode. Several factors determine the maximum flash output: distance to the subject, the aperture size, the scene brightness and film sensitivity (ISO) in use.

## The Guide Number

Flash exposure is determined by flash-to-subject distance. This is because the amount of light emitted by the flash (the flash output) decreases as it travels away from the source. The measure of a flash unit's output is called its guide number or GN. The guide number quantifies the relationship between brightness, distance, and film sensitivity and assists in calculating aperture and distance values.

The formula for determining the aperture to use with a given ISO is aperture = guide number/distance. Thus, the higher the number, the greater the output of the flash. While this formula was essential in the days of non-automatic flash units, the primary value of GN with highly automated Speedlights is for comparison purposes. The higher the number the greater the distance the flash will illuminate. Doubling the guide number actually results in a quadrupling of power. Hence, the SB-25 or SB-26 will have a far greater "reach" than that of the built-in Speedlight.

*Note:* In the United States, guide numbers are expressed in feet. Consequently, they are 3.3 times larger than the corresponding metric guide numbers that are generally used elsewhere in the world.

## Flash Synchronization

For proper results, an electronic flash must fire when the focal plane shutter is completely open. This shutter consists of two curtains which move in sequence across the film. The first curtain opens, uncovering the film for exposure, and then the second cur-

**Diagram of the Multi Sensors:**
① **Shutter Curtain,** ② **Bottom of the Mirror Chamber,** ③ **Condenser Lenses,** ④ **Five-segment TTL Multi Sensor**

tain closes providing a light-tight cover over the film again. Exposure time is changed by releasing the second curtain either sooner or later. Thus, the fastest synchronization speed for electronic flash is the highest shutter speed at which the first curtain has completely uncovered the film and the second has not yet begun to close. The N70/F70's vertical shutter design allows a sync speed of 1/125 second or longer.

The N70/F70 automatically sets the right sync speed: usually at 1/125 second to 1/60 second in most exposure modes. There are just a few exceptions: in Shutter-Priority mode (S), you can set speeds from 30 seconds to 1/125 second. Should you set a higher speed, such as 1/250 second, the camera automatically corrects it. Operator errors are thus impossible.

In Manual mode (M), a range from 30 seconds to 1/125 second is also available. The "Bulb" ("B") setting is an option as well. This is used for long time exposures and can be combined with flash. The flash triggers at the beginning of the exposure in this case, right after the shutter opens. Plus, there are also slow sync settings in the Night Scene and Motion Effect Vari-Programs. The N70/F70 sets the correct exposure time, as seen in a previous chapter.

## Multi-Sensor Technology

Like its "big brothers" the N90/F90 series cameras, the N70/F70 incorporates a Multi Sensor to detect flash exposure. The metering cell is divided into five sectors. Before the flash fires, the Sensor tests the entire scene with imperceptible Monitor Pre-Flashes. (If D-type lenses are used, distance information is integrated into the exposure equation). This makes it possible to determine which segments to ignore (out of focus areas, especially) and where the main subject is located (the section in sharpest focus).

Now the system knows (in advance) exactly how much light is needed for a pleasing rendition of the scene. Surprisingly, 3D Multi-Sensor Balanced Fill Flash operates with all three metering patterns: Matrix, Center Weighted and Spot. For maximum automation, choose Matrix metering.

*Note:* The above works with the built-in head or accessory Nikon Speedlights connected to the hot shoe or in remote operation with TTL cables such as the SC-17. The accessory units offer a higher Guide Number; farther "reach", so to speak. The built-in Speedlight is deactivated when an accessory unit is attached, reducing drain on the camera's lithium batteries.

## Nikon Flash Metering

The entire 3D flash metering process is relatively complex but can be described in layman's terms as follows.
1. The built-in flash or an SB-25 or SB-26 Speedlight fires a maximum of 16 weak pulses during the delay between tipping the reflex mirror up and opening the shutter.

2.  The neutral gray shutter curtain (still closed at this point) reflects the light from the test flashes onto the MS.

3.  The metered values for each of the five sectors are input into the N70/F70's computer.

4.  If a D-type lens is in use, it transmits the subject distance to the flash meter at the same time.

5.  The computer can calculate the theoretical metering values for the five sectors using the distance, the information provided by the pre-flashes and the working aperture selected by the Matrix system for appropriate background brightness.

6.  Should the values in any of these five sectors deviate drastically from the predicted values, those sectors will be ignored during the following light control phase.

7.  After the camera has analyzed the scene, the actual exposure process is activated. The aperture is closed to the working setting and the first shutter curtain opens.

8.  Flash is triggered for the exposure.

9.  The Multi Sensor reads the light reflected off the film during the exposure, including light from flash and ambient light.

10. As soon as an adequate exposure has been confirmed, the flash's output is terminated and the second shutter curtain closes the image area.

11. The reflex mirror flips back down; the aperture opens up all the way again so you can view the scene on a bright screen.

*Note:* Monitor Pre-Flash is possible only with the built-in Speed-light or a Nikon SB-25 or SB-26. With other Speedlights, the Multi Sensor operation continues, however. All exposure analysis then occurs during the exposure itself. Flash exposure is still more accurate than with a conventional metering with a single cell system.

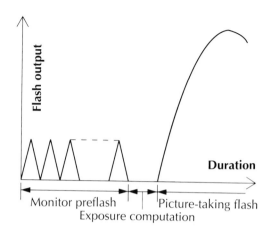

**Autoflash with Monitor Pre-flash: with N90/F90 and SB-25.**

Flash output

Duration

Monitor preflash | Picture-taking flash
Exposure computation

The test flashes are so weak, and triggered so close to the main flash, that you will not even be aware of them. Monitor Pre-Flash should not be confused with those used to combat red-eye with the SB-25 Speedlight.

**An advantage to using a D-type lens with the N70/F70; the most natural lighting results with flash are made possible by 3D Multi-Sensor Balanced Fill Flash.**

# Multi-Sensor Balanced Fill Flash

This is the term used by Nikon for the process, as mentioned earlier. Unlike less sophisticated systems, this does not produce a bright subject against a black background because flash and ambient light are balanced for a pleasing overall effect.

Using an AF Nikkor that is not of the D-type results in the loss of the distance information, but the end result is still excellent in many circumstances. The system can still detect the likely position of the subject in the frame (off-center, perhaps) but not as accurately. In our tests, D-type lenses were most useful in situations of extreme contrast (a groom in a black tux against a white backdrop which is reflecting bright light, for example).

### 3D Multi-Sensor Balanced Fill Flash In Practice

Let's examine a brief example which will make the advantages of each option much clearer with the N70/F70 and an SB-25 or SB-26.

We're shooting in a hall with mirrors on the walls, which will reflect flash light. With a conventional system, underexposure of the main subject will occur since the amount of reflected light is so great. The system will stop flash output too early, assuming that the entire subject is extremely bright.

The N70/F70, however, will recognize the primary subject and note the unusual reflectance of the background. The sectors of the latter will be ignored in the exposure calculations. The final picture will show a nicely lit bride and groom against an extremely bright background.

In the opposite situation, the couple are standing in front of a wide church door which is open. The interior of the building is completely dark. Monitor Pre-Flash indicates that much of the light was not reflected back. Hence, the N70/F70 ignores the sectors which compose the doorway area as nonrepresentative of the subject. Unlike conventional metering, the result will be perfect: the subject will not be overexposed!

Take another example of a typical family room with a coffee table and a couch behind it. Your children are sitting on the couch with birthday gifts stacked on the table in the foreground. A less sophisticated flash metering system will render the gifts overexposed with the youngsters unduly dark. The N70/F70, however,

will recognize the true subject. With 3D Multi-Sensor Balanced Fill Flash, the camera "knows" that the foreground is much closer than the focused point. As a result, it ignores the sectors which cover the gifts, exposing for the subject instead.

## The Built-in Speedlight

Natural light is very appealing but sometimes you need a touch of flash to fill in shadows, to fully saturate colors, and to balance foreground and background exposure. The built-in Speedlight will do all that with the technology already described. Unlike accessory units, it is small, hidden until needed, and adequately powerful for close-ups and much of outdoor photography.

**The built-in Speedlight of the N70/F70 is one of the most sophisticated of any camera. When activated, the N70/F70 is capable of advanced flash operation such as 3D Multi-Sensor Balanced Fill Flash, Rear-Curtain Sync, Slow Sync, and Red-Eye Reduction.**

Its Guide Number is surprisingly high: at ISO 100 it is 14 in meters or 46 in feet. That's a lot lower than that of most Speedlight models, but still useful. Its primary purpose is for close-ups or to add a hint of extra light in bright outdoor conditions.

The N70/F70 warns you when the available light might not be adequate, with a small green lightning bolt symbol in the viewfinder. But this should not be the only hint that flash is appropriate. Because it will fire any time the head is popped up, use it in daylight to lighten hard shadows cast by a hat brim, for example. And use it anytime the background is bright, as in back lighting at the beach to even out the contrast of the scene.

As soon as the flash symbol in the viewfinder turns red, you are ready to fire. The trigger is locked until then, so you cannot take a picture by mistake during the recycling process. After the exposure, the flash symbol reappears after a few seconds. If not, the battery is weak and should be replaced. If the flash symbol blinks, this is a warning. The subject was probably underexposed. Move in closer and try again. Or, switch to a film of higher ISO, or try a wider aperture (such as f/4 instead of f/11).

The flip-up Speedlight is extremely versatile due to the technology previously described. To the best of our knowledge, no other system includes such a versatile built-in unit. More importantly, it allows for a variety of effects with the various modes which can be selected: Slow Sync (at long shutter speeds), Red-eye Reduction (with an incandescent lamp), Flash Exposure Compensation (to intentionally brighten or darken the picture), and Flash Exposure Bracketing (varying flash output automatically from one frame to the next).

**Distance Range**

With any flash unit, range is determined by the Guide number, with film speed (sensitivity to light ) the deciding factor. At ISO 400, any flash unit illuminates more distant subjects than an ISO 100 film. The following table provides a rough estimate of the range you can expect with the built-in Speedlight, at various apertures, with three different film speeds.

| ISO 100 | ISO 200 | ISO 400 | Range |
|---------|---------|---------|-------|
| f/1.4 | f/2 | f/2.8 | 6.6-32.5 ft |
| f/2 | f/2.8 | f/4 | 4.6-23.0 ft |
| f/2.8 | f/4 | f/5.6 | 3.3-16.4 ft |
| f/4 | f/5.6 | f/8 | 2.3-11.5 ft |
| f/5.6 | f/8 | f/11 | 2.0-8.2 ft |
| f/8 | f/11 | f/16 | 2.0-5.9 ft |
| f/11 | f/16 | f/22 | 2.0-4.3 ft |
| f/16 | f/22 | f/32 | 2.0-3.0 ft |

**Flash Obstruction Concerns**

The built-in flash is not very high above the lens, although the N70/F70's design makes it higher than many. As a result, certain

large lenses will block some of the light, making for unevenly illu-
minated pictures. Generally, mid-range telephoto lenses should
not be used, particularly with a lens hood or shade which creates
serious blockage problems.

Normally, we recommend the use of a lens hood or shade to
minimize flare (stray light striking the front lens element). How-
ever, when the built-in Speedlight is used, you will generally have
to remove the hood for subjects closer than 15'. In extremely bright
conditions, this can create problems, making an accessory Speed-
light like the SB-26 far more useful. It extends far above the cam-
era, so most lenses/hoods will create light cutoff. (Or it can be
removed from the body using an SC-17 TTL extension cable).

Another important item to consider with focal length is angle of
view. The built-in Speedlight will cover the angle of view of lenses
of 28mm or longer. It cannot illuminate a wider image angle.
Remember this especially when using zoom lenses like the AF 20-
35mm f/2.8D. Also, the "Macro" (close focusing) option of some
zoom lenses cannot be used with the built-in head. The illumina-
tion parallax would be too large; the light would miss the subject
entirely.

The closer the subject, the more likely the problem: part of the
flash light is blocked, resulting in so-called vignetting. The lower
portion of the image will be darker.

## Reducing Red-Eye

Since small built-in flashes became fashionable, the red-eye syn-
drome has become more and more common. Whenever a flash
unit is close to the lens axis, this is more likely to occur. Red-eye
is prevalent in dim light because the pupils are wide open, expos-
ing the full surface of the retina. The light reflects off the red blood
vessels and the effect is highly visible in the final picture. Several
tactics can be used to reduce this ghoulish effect:

❑ Brighten the room as much as possible.

❑ Use a wide-angle (such as a 35mm) lens instead of a telephoto
(such as 80mm) when appropriate.

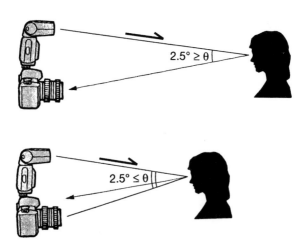

Red-eye is caused by light reflecting off the subject's retina and occurs when the angle of reflectance is less than 2.5 degrees. Eliminate red-eye by keeping the camera close enough to the subject to ensure a larger angle of reflectance.

❏ Set the Red-Eye Reduction function. (Switch to flash mode on the N70/F70, third section on the LCD panel, and use the control dial to select the eye symbol while holding the SET key). With the built-in head or the SB-26, a lamp illuminates before the exposure. This white light makes the pupils contract to some extent. The SB-25 generates a series of brighter pre-flashes for the same purpose.

❏ Use an accessory Speedlight which sits higher above the camera/lens.

❏ Move the flash unit at least 1' away from the lens axis. This is the single most useful strategy for preventing red-eye. An off-camera TTL cable such as the SC-17 is required.

*Note:* When the SC-17 cable is used, all functions continue to operate as if the Speedlight were attached directly to the hot shoe. With the SB-26, Wireless Off-Camera flash is also possible but with fewer functions and without TTL flash metering.

# Flash Exposure Control

The small built-in Speedlight allows for fine-tuning of output as with the large SB-24 to SB-26 models which contain their own Exposure Compensation controls. This could come in handy when experience suggests that fill flash should be even more subtle than the computer would usually set.

To access "Flash Exposure Compensation" mode select the second section from the left on the LCD panel. Press the flash symbol with "+/-" while holding the Function key. This only works, by the way, when the flash is on. Finally, press the SET key as usual and select the desired correction factor: "+" numbers for greater output (to make flash the predominant light source) or "-" numbers (for gentler fill lighting). The compensation factor remains effective as long as the flash is on. You can, of course, return to zero manually.

*Note:* This is also useful with accessory Speedlights which do not have output control buttons. If the SB-24, SB-25 or SB-26, is used, Flash Exposure Compensation set on the N70/F70 takes precedence over any set on the Speedlight.

## Flash Exposure Bracketing

This function is one rarely available with built-in flash. As with regular Exposure Bracketing, increments of 0.3 EV, 0.5 EV, 0.7 EV and 1 EV can be selected. With slide film we use the first and with print film the latter to vary the flash exposure from one frame to the next.

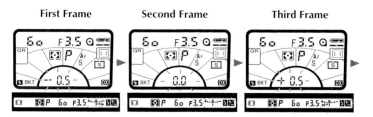

**First Frame**    **Second Frame**    **Third Frame**

Flash Exposure Bracketing enables you to automatically take three different flash exposures of the same scene. Compensation values can be selected in 1/3, 1/2, 2/3 or 1 EV steps. (Here, the N70/F70 is set for 1/2 EV steps).

To do so, turn the flash on again. If using an external Speed-light, set it to "TTL." Then hold the Function key and turn to the "Bracketing" mode (far left section on the LCD panel) until "BKT" blinks in the display. Then continue as usual with the SET key and the control dial to select the factor desired.

The camera now takes three shots with the selected increment: one frame underexposed by flash, the next correctly exposed, and the third with greater flash output. In Matrix metering, the overall exposure will be correct but the amount of flash light will differ among the three frames.

*Note:* You will need to press the trigger three times even in Continuous film advance to complete the flash bracketing series. (In many cases the flash needs this extra time to recycle between shots).

Flash Exposure Bracketing is canceled automatically after the three pictures are made. To reactivate it, press the Function key briefly and then press the SET key. The last selected value reappears immediately and you can continue with another flash bracketing series. Turning the camera or the flash off cancels the function. Even then, the last used Compensation factor reappears when the function is reactivated at a later date.

## Slow Flash Synchronization

If you are using flash outdoors at night (or in a huge, dark area) the main subject will be nicely illuminated but the background will usually be rendered as black. That's because the normal, short (1/60 second) exposure time does not give the ambient light a chance to register on the film. The resulting effect looks unnatural in a photo because our eyes did see some light in the surroundings.

For a more "natural" effect, longer exposures with flash should be used. You can allow the N70/F70 to do so automatically by switching into Flash Synchronization mode (third from the left) and selecting "SLOW". Remember that this is only effective in Program and Aperture-Priority modes. The camera will then select a long shutter speed that exposes the background appropriately.

*Note:* If the above is impossible because it is simply too dark (especially outdoors without background lights) a "LO" warning symbol appears in the viewfinder. Switch to a wider aperture, to a film of higher ISO or a lens with wider maximum aperture.

Slow Sync tends to make the exposure times far too long when hand-holding the camera. A tripod or other solid support becomes an unavoidable necessity. At least set the camera on a railing, rock, or car roof, tripping the shutter with the self timer to prevent blurred images.

## Second Curtain Sync

Cameras generally synchronize flash with the first shutter curtain. In other words, the flash is triggered as soon as the image window is fully open. This is fine with static subjects during long exposure times. But let's say your subject is moving. Because flash typically fires at the start of the exposure, the effect will be unnatural. Motion streaks created by ambient light will appear to precede the subject.

If you want the streaks to follow the subject, the flash exposure must be made at the end of the long ambient light exposure. That's why the N70/F70 includes the ability to synchronize with the second or "rear" curtain. This produces a light trail behind the subject for a completely different result with a moving subject.

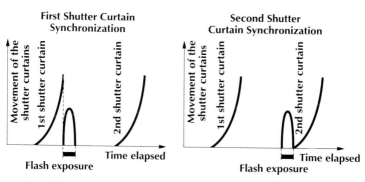

Graphic Representation of First and Second Shutter Curtain Sync

Let's consider a car at night. With normal flash synchronization, the light trails would appear in front of the car, a totally unnatural impression. For the second shot, switch the N70/F70 to Rear Curtain Sync. Now, the motion blur follows the car in the final picture. This representation would create a convincing impression of movement.

To access this function, set the "REAR" option in the flash sync section of the LCD panel. (REAR is tied to SLOW in Program and Shutter Preferred modes.) Remember that turning the camera or the flash off does not clear the setting; it must be cleared manually. (You can also revert to the factory programmed settings by selecting "0" in the Quick Recall "QR" option.)

## Nikon System Speedlights

All the functions described so far are available with either the lift-up flash head of the N70/F70 or some of the accessory Speedlights which mount in the hot shoe. This is important because several of the Speedlights described are very "basic", without many built-in functions. This is no problem because the N70/F70 includes a wealth of flash modes: Slow Sync, Rear Curtain Sync, Red-Eye Reduction (with the SB-24, SB-25 and SB-26 only), Flash Exposure Compensation and Bracketing.

We recommend one of the Speedlights for extra power and (with some) an "autofocus assist illuminator" discussed elsewhere. Another advantage is that the larger Speedlights sit well above the lens axis and can be moved off camera with an accessory flash cord for less risk of red-eye and for more pleasing illumination.

## Speedlight Compatibility

All of the Speedlights described in this guide will operate with the Multi-Sensor Balanced Fill Flash system of the N70/F70 when used with AF Nikkor lenses. With conventional Nikkor lenses, Automatic Balanced Fill Flash is provided. It is less sophisticated but still better than the earlier flash technology.

However, as previously mentioned, only a few are capable of producing Monitor Pre-Flashes for the ultimate in flash exposure

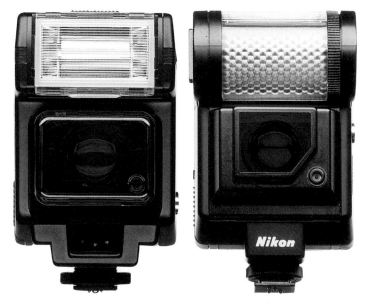

**Nikon SB-22 Speedlight**          **Nikon SB-20 Speedlight**

accuracy. And red-eye reduction is possible only with the SB-25 and SB-26 in addition to the built-in flash.

The integral flash must be closed when an external Speedlight is mounted or connected to the hot shoe with a TTL cable for off-camera operation. As we'll see, it does operate in tandem with the new SB-26 in Wireless Remote operation.

Most Nikon system flash units can be used with the N70/F70. The new top of the line model is the SB-26. The SB-25, which replaced the SB-24, is also available and is similar to the SB-26 except for the Wireless Remote feature. All of the Speedlights mentioned (except the SB-16B) incorporate a focus assist illuminator, useful in low-light conditions, when even manual focus is impossible.

A red lamp on the front of the Speedlight projects a near-infrared pattern on the subject as a target for the AF detection sensors. As the brightness level increases, this pattern becomes unnecessary. In moderate lighting it does serve another purpose: enabling the

N70/F70 to focus on a blank wall or other low contrast subject. However, as the light level increases, the red pattern is eventually overwhelmed by sunlight, eliminating its assist value.

The following is a brief description of each current Speedlight. At least one is sure to have the power you need at a price within your budget.

## SB-23 Speedlight

This is the smallest and least expensive option, with a fixed head useful for lenses of 35mm and longer. Its aperture and distance charts are useful for easy reference when using the N70/F70. Recycle times are extremely brief (2 sec.) and four alkaline AA's will offer some 400 bursts. With a Guide Number of 66 in feet (20 in meters) at ISO 100, it manages to reach about 16' at f/4. In this respect, the flip-up head of the N70/F70 is almost as useful.

As compact and convenient as this unit may be, you'll probably want one with more power. Still, the SB-23 has some value, as do any of the accessory Speedlights. It will not drain the (expensive) lithium batteries of the camera, it does sit higher above the lens axis, and can be used off-camera with an SC-17 cable.

## SB-22 Speedlight

This is a slightly more powerful alternative with a higher Guide Number of 83' (25m) at an affordable price. The angle of coverage is suitable for lenses of 35mm and longer. With the wide flash adapter (diffuser), this can be expanded to suit 28mm lenses with some reduction in Guide Number.

The head can be tilted upward (to 90 degrees) for bouncing flash from a ceiling. It can also be tipped downward to -7 degrees, useful for extreme close-ups (so the flash does not illuminate the area above the subject). The recycle time is approximately 4 seconds and a set of four AA batteries (alkaline or rechargeable NiCds) will power up to 200 bursts. As with any Speedlight, these figures are estimates. The actual recycle time/number of flashes will vary depending on the situation so use these for comparison only.

*Hint:* For reasons which remain a mystery, we often see people shooting with the flash head tilted partially upward. Unless intentionally bouncing light from a ceiling this makes little sense. Do not tilt the head unless you want uneven subject illumination.

## SB-20 Speedlight

The SB-20 manages a Guide Number of 100' (30 m) again with respect to ISO 100, with a lens of 35mm focal length. The focal length is important here as the unit's reflector can be set for three different angles of coverage: corresponding to 28mm, 35mm and 85mm. This means the amount of light is concentrated to match the area of coverage of longer lenses. Naturally, this increases "reach" too, as the Guide Number increases at the longer settings.

The head can be tilted through 90 degrees for bounce flash. A set of AA batteries lasts for about 150 flashes with a recycle time of about 7s.

## The SB-25 and SB-26 Speedlights

The SB-26 was introduced at the same time as the N70/F70 and became the top of the line Speedlight in the Nikon system. Its predecessor, the SB-25, is similar to the SB-26 in most ways; only a few operations are performed differently and an additional function is provided with the SB-26. Both reach a high Guide Number of 164 (in feet, 50 in meters) when the zoom head is set for 85mm. Given its high power, the SB-26 achieves remarkable ranges. With

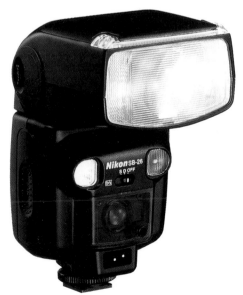

The SB-26 Speedlight is currently the top of the line model. It includes all SB-25 functions and adds a few others.

settings of 85mm and f/4, illumination reaches over 40' at ISO 100. This makes true telephoto flash possible, especially with lenses up to 200mm and even longer with faster film.

Other features include a motorized zoom head which can match focal lengths from 24mm to 85mm. With the built-in Wide Flash adapter, this can be expanded to 20mm with the SB-25 or 18mm with the SB-26. When the N70/F70 is used with an AF Nikkor lens, the angle of coverage of the flash is automatically set to match the focal length of the lens; however, the head can also be adjusted manually with a touch of a button. The head will tilt from -7 degrees to 90 degrees and will also rotate to 360 degrees to bounce flash from a wall.

A built-in white card can be used to kick in a bit of fill (to add catch lights to the eyes) when used in bounce flash. However, this only works with close-up subjects as the card is very small.

**The SB-24, SB-25 and SB-26 all include a large LCD panel on the back of the Speedlight for monitoring current settings as well as the range of the flash at any given f/stop.**

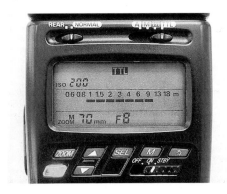

A large LCD display panel provides full information on the operation of the SB-25/SB-26 including a variable bar graph (distance scale) denoting flash range; this varies with the aperture selected. Other information includes exposure range and mode, zoom head setting, effective aperture control and distance range and manual output. The film speed, aperture in use, etc. are automatically transmitted to the SB-25/SB-26 from the N70/F70. The SB-25/SB-26 can also be set for "strobe" to fire up to 160 times on one frame for motion studies, such as a golfer's swing.

Four AA alkaline batteries or corresponding NiCds serve as the power source. The recycle times vary between 7 and 30 seconds

for alkaline cells. A set of batteries lasts for about 100 flashes at full power. Since full power is not often required in Auto modes, one can generally count on more performance from a set of batteries.

The primary advantage of the SB-26 over the SB-25 is the addition of the Wireless Remote Flash capability; an SB-26 can be activated without a cable connecting it to a Nikon camera. This is achieved with a built-in "slave cell": a sensor which detects the light from another Speedlight and triggers automatically.

*Note:* Tips on using the many functions are beyond the scope of this guide. For more advanced information, read the *Magic Lantern Guide to the SB-25/26.* Wireless Remote operation is not "simple". Until you are ready to experiment, we do suggest the use of the SC-17 TTL remote cable which maintains full automation.

## Wireless Remote Operation

In Wireless Remote operation, the SB-26 (or several) are triggered automatically by the flip-up head or another Speedlight on the hot shoe or connected to the N70/F70 with an SC-17 TTL cable. Unfortunately, any SB-26 used in Wireless mode does not offer TTL auto flash control. In other words, the flash output is controlled by a sensor on the front of the SB-26, and not by the "through the lens" sensor. There is no way for the camera to communicate settings, proper exposure, etc. to the flash. However, one or more Speedlights connected to the camera body can still be used in TTL flash metering. Or you can set both for non-TTL Auto Flash (A Mode) or fully manual control for varying power output from full to 1/64 power. This is useful when using an accessory Flash light meter or other advanced techniques.

In truth, you can use multiple Wireless SB-26 plus several other Speedlights connected with SC-18 and SC-19 remote TTL cords. Once everything is set up, the N70/F70 should be set to Aperture Priority Auto mode with the f/stop selected on the lens. Flash Exposure Compensation can also be used. On the Wireless Remote SB-26, the aperture must be manually set. Through the selection of an f/stop on that unit, you can vary its output: increase or decrease the output using an aperture smaller or larger respectively than set on the camera.

**Hint:** Note the small switch on the front of the SB-26. In Wireless Auto use, this should be set for "D": delay mode. Now the Wireless Remote unit will fire a split second after the "master" flash so it does not affect overall TTL exposure. This prevents underexposure of the subject.

## Indirect Flash Techniques

Direct frontal lighting with on-camera flash is oh so practical and oh so flat. Light aimed directly at the subject creates a good record shot of the individual but is far from pleasing. Then, too, the shadows which fall on the background are distracting, a sure sign of a snapshot.

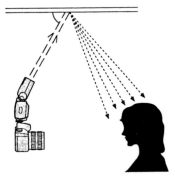

**Softer, more diffused light is created by tilting the flash head to bounce the light off a ceiling.**

The overall look can be improved by aiming the flash at a ceiling, for example, which "spreads" the light over the subject. Naturally, this requires a Speedlight whose head can be tilted. You gain additional flexibility with a model whose head can be swiveled as well, like the SB-25 and SB-26. You're no longer limited to horizontal format but can also flash indirectly in vertical format quite easily.

**Look for descriptive details to photograph. Loaves of bread stacked in the window of a country bakery express the simplicity and charm the photographer found there.**

Photographing animals in captivity may not be as exciting as going on safari, but it can produce some rewarding images. For more natural portraits of zoo animals, bring a long lens so you can fill the frame with your subjects and crop out bars and cages. Use large apertures so the background is a blur, reducing the chance of spoiling the picture with evidence of the animals true habitat.

This series illustrates a variety of possible compositions for a single subject. The photographer's goal was to document an ornate fence. The bottom photo resulted from the photographer seeing the railing in an attractive setting and simply snapping a picture of it.

On the left, the photographer moved in to show more detail and composed the photo vertically to match the format of the fence post. The results were not completely satisfying to the photographer. Although the railing is dominant in the scene, the distracting background and flowers draw the viewer's attention.

After studying the fence further, the photographer reframed the image as a horizontal composition. It created a stronger graphic photograph with all the important elements the photographer wanted. The ornamentation is prominent, even though most of the post is cropped out. The flowers frame the decorative ironwork rather than compete with it.

⌂

Use a polarizing filter to get rid of light reflections on glass or water. It will even clear reflected sunlight off the water's surface and allow and image reflected on the water to be photographed.

⌐ Including objects in the foreground can add the illusion of depth to a landscape photograph. Here branches and leaves accentuate the mountain monastery in the distance. To create this effect, choose a large aperture by setting exposure with the Aperture-Priority or Manual mode. This makes objects in the foreground a soft blur. Use the Spot AF sensor or focus manually on the subject to ensure it is the sharpest element in the photograph.

**The head of the SB-25/SB-26 will tilt up to a full 90 degrees for bounce flash. Use the built-in white card to bounce some light directly onto the subject to create catchlights in the eyes.**

**Hint:** For best results, the bounce surface should be pure white. Otherwise an unpleasant color cast can be expected. Move close to the subject. In bounce flash, there is a lot of light loss because of the distance it must travel and because it is diffused over a large area. Use a high power Speedlight or ISO 400 film indoors in low light.

Bouncing light from a ceiling is convenient but creates one problem: people can be rendered with dark eye sockets as the light is coming from above. In our experience, a light-modifying accessory can produce more pleasing results with the flash on-camera or off. These mount on the Speedlight, adding a bounce surface or diffusing the light depending on the type of device purchased. LumiQuest is but one manufacturer which offers a variety of effective accessories, most useful at distances up to 10'.

If you must use direct, on-camera flash, ask your subject to move away from the wall so his shadow will not fall on the background. As an alternative use the SC-17 TTL cord to move an accessory Speedlight off-camera. Hold it high so shadows fall behind the subject or bounce the light off the ceiling or wall.

**In order to highlight the necklaces without cropping out the setting, a filter was used that diffused the edges of the photograph, but left the center sharp. The scene is still recognizable as a window display and the viewer's eye is drawn to the jewelry because it is in sharp focus.**

## Multiple Flash Photography

Light striking the subject from a single direction does not provide much definition. An umbrella made of highly reflective material improves the quality of the illumination. Flash is directed into this accessory and bounced back onto the subject. The light becomes "harder" as a more reflective surface is used. Aluminum umbrellas, for instance, produce a much harder light than a matte umbrella made of white material.

If you own several Nikon system Speedlights, TTL flash control can handle up to four units connected via the appropriate SC cables and adapters (most newer Nikon system flash units are suited for this purpose). Mount each on a light stand or tripod, positioned appropriately. One might brighten the background, another provide backlighting on the subject's hair, another might be bounced off the ceiling and the last might provide gentle fill lighting.

If you use an SB-26 (or older SB-24 or SB-25) you can adjust flash output individually on the back of each unit. With the Multi-Sensor TTL exposure control, the N70/F70 will provide accurate exposure. Use an umbrella or other light modifying device on some of the Speedlights, if desired.

Reduce output on one or two to provide moderate fill lighting. Experiment until you find the most pleasing effect but do watch the distance scale on the back of the Speedlights. This will guide you as to the range of each unit at the aperture and Exposure Compensation levels used. Background shadows can be eliminated, highlights added to the hair, and depth added to the face, depending on the techniques employed.

## Tips for Fill Flash

Some photographers will use flash only as last resort, preferring the more "natural" look possible with ambient light. Yet, flash can be highly useful, producing pictures most viewers will prefer. Even in front lighting, Matrix-Balanced Fill Flash automatically softens shadows and produces more detail in both light and dark areas.

We strongly recommend that you try flash on sunny days for even more foreground illumination, more saturated colors and

sharper detail. If you have yet to use fill to enhance outdoor pictures, try it with a broad variety of subjects, from people to flowers and still lifes.

In some situations, ambient light alone may be more aesthetically pleasing, more effectively capturing atmosphere or the play of light and shadow. Consequently, you may wish to shoot two frames in conditions where flash is not obviously required: one with and the next without. Compare the results after the pictures are developed to establish your own preferences.

**Hint:** When a Speedlight adds only a hint of fill in bright conditions, on-camera flash produces highly acceptable results. If you want more directional light, however, remove the Speedlight from the N70/F70 using an SC-17 TTL cord. Or use an SB-26 in Wireless Remote mode, with the flip-up head adding an extra bit of frontal fill lighting.

In either case, hold the remote flash above and to the side of a portrait subject. Try several flash positions with other subject types such as nature close-ups. Watch the distance range on the scale of suitably equipped Speedlights and check for the flash exposure confirmation signal in the viewfinder after the picture is taken.

## Flash Accessories

### Nikon Accessory Cords and Adapters
***SC-17 TTL Remote Cord:*** One end of this 4.9' (1.5 m) coiled cable has a flash connector which slides into the shoe of the N70/F70. It relays information between the camera and flash. The other side of the cable has a flash shoe and two multi-flash sockets for attaching any Nikon systems flash unit or the connection of additional flash units via additional TTL cables (SC-18 or SC-19). The SC-17 allows all TTL flash functions with all camera-specific options The SC-17 is necessary for using the flash off-camera or in conjunction with a flash bracket such as "Stroboframe".

**TTL Remote Cord SC-17**

***Multiflash Sync Cords:*** TTL extension cables SC-18 and SC-19 are also called "TTL-Multiflash-Cords." These feature connectors on both sides for Nikon multiflash system components (such as the

**TTL Multiflash Sync Cord SC-18**

SC-17 Cord, Multiflash Adapter AS-10, and Nikon systems flash units). They transmit all Nikon systems commands with all camera-specific options.

***TTL-Multiflash Adapter AS-10:*** For multiple flash with more than three flash units. One flash mounts directly on the AS-10's shoe, the rest are connected to its multiflash sockets using the SC-18 or SC-19 cord.

**TTL-Multiflash Adapter AS-10.**

## Stroboframe® Flash Brackets

Most people prefer the results from off-camera flash with a professional flash bracket such as those manufactured by Stroboframe® This is due to the fact that more natural-appearing illumination can be achieved by positioning the flash high above the lens. Light has a more natural effect (like sunlight) when it comes from the top. Flash units mounted directly on or next to the camera pro-

duce unflattering light with harsh shadows. With a bracket centered high over the lens, harsh shadows fall below and behind the subject. The red-eye phenomenon becomes more pronounced the closer the flash head is to the optical axis. This problem is also solved by using a bracket which positions the flash unit high above the camera.

Stroboframe offers flash brackets and adapter plates for use on the Nikon N70/F70. One innovative feature is that the bracket position the flash unit above the camera even when the camera position is changed for vertical and horizontal formats. All Stroboframe flash brackets accept a shoe-style flash mount to accommodate Nikon system flash units and accessories. Stroboframe offers Quick Release Flash Mount which is also compatible.

## Final Advice

The N70/F70 and the flash units we've discussed, are computer systems packed with electronics. Unlike computers at home, however, a camera system is not grounded, and can be susceptible to static electricity. If the N70/F70 locks up or functions erratically, don't panic. First try just turning the camera off and on. If that doesn't clear things, take all the batteries out of the camera, wait a few minutes and replace them. This seemingly simple solution can often clear problems and poses no risk to the camera.

If the camera fails to function as expected, don't tamper with it! Take it to a qualified Nikon dealer. In the event that it requires repair, this dealer can assist you in sending the camera to an authorized Nikon service center. If the camera is within the manufacturer's warranty period, proof of purchase is required, so don't forget to bring a copy of your receipt with you.

# Nikkor Lenses

Nikon has established an enviable reputation among professional photographers, partly due to the excellence of Nikkor lenses. To achieve this goal, Nikon offers both exceptional optical quality and a comprehensive selection. Amateurs benefit on both counts. The lens that helps the pro earn his living can be used by the photo enthusiast for pictures of superior quality.

## Lens Compatibility

The N70/F70 was designed primarily for use with AF Nikkors, particularly the D-type that transmit the distance setting to the matrix metering system. All camera functions will operate with any such lens. However, in keeping with Nikon's policy of compatibility, the N70/F70 will also operate with the older manual focus Nikkors: the AI and AI-S Series. Most of them are compatible with the N70/F70 with limitations. After all, not all computerized technology can interface with the older mechanical approach which had been used for decades before the invention of the N70/F70.

Manual focus lenses will not autofocus, of course, but most will maintain the use of the focus assist signals in the viewfinder. Naturally, the latest high-tech features cannot be accessed. Of program modes, Multi-Sensor flash and Matrix metering especially.

Focusing is not really a problem with such a lens thanks to the extremely bright viewfinder installed in the N70/F70 which is the brightest of any Nikon except for the N90s/F90X. For help with manual focus, watch the focus indicator signals in the viewfinder.

**Hint:** In spite of the above, we still recommend AF Nikkor lenses to fully utilize the N70/F70's features, Advanced Matrix metering especially and superior flash exposures. If you're buying new equipment, the price will not differ substantially. But if you already own some manual focus Nikkor lenses, do not immediately sell or trade them all. Do add at least one AF Nikkor, however; perhaps a zoom lens you are most likely to use frequently.

Modern zoom lenses offer excellent quality and versatility at reasonable prices. A single zoom lens with a wide range of focal lengths can replace several fixed focal length lenses. And they quickly allow a photographer to shoot the whole scene...

## AF Nikkor Lenses

The number of AF Nikkor lenses has grown to 33 and 23 of them are of the D-type with the Distance Data Chip. This includes the AF-I series telephotos with built-in focus motor. Such a wide range of high quality lenses gives you an enormous creative scope, from fisheye lenses which encompass a 180 degree view to Micro (macro) lenses for extreme close-up work and on to the long telephoto lenses for sports and wildlife. And best of all, there's a full assortment of zoom lenses with maximum versatility packed into a single barrel.

## The Zoom Lens Debate

Zoom lenses were once scorned because the early models produced mediocre image quality at best. But the current generation has been improved dramatically, to the point that most professionals include at least one in their arsenal. Outselling single focal

length lenses (called prime or fixed lenses) by eight to one, this type has become the standard for most photo enthusiasts.

Thanks to aspheric and low dispersion optics, Close Range Correction and other technology, the AF Nikkor zooms produce exceptional technical quality to 8 x 10 for the less expensive lenses and up to 16 x 20 enlargements for the "pro" models. The latter types meet or exceed the resolution and contrast capabilities of prime lenses.

It is the ease of use and practical advantages which make zoom lenses so popular. A push or a turn of the ring suffices to change composition or framing with a choice of several familiar focal lengths and many in between. You are not restricted to specific focal lengths but can zoom continuously for precise framing at 39mm, 46mm, 77mm, and so on. More importantly, a single zoom like the AF Nikkor 75-300mm f/4.5-5.6 takes up much less room in a camera bag than the three or four prime lenses it replaces. And while AF Nikkor zooms are not cheap, you can acquire one for a fraction of the cost of several prime lenses.

## Prime vs. Zoom Lenses

In spite of all the accolades, we'll admit that zoom lenses are not exactly ideal in every respect. There are definitely some tradeoffs in return for the convenience. Let's consider the drawbacks you may have heard mentioned and how each can be overcome for excellent results.

First, maximum apertures are indeed small in comparison to most "prime" lenses. In particular, the compact zooms with a broad range of focal lengths are unlikely to be "fast". Their maximum apertures seem small, especially in comparison to the traditional 50mm f/1.8. With today's AF Nikkor zoom lenses, a maximum aperture around f/3.5 or f/4.5 is common. Typically, this diminishes to f/4.5 or f/5.6 at longer focal lengths.

Frankly, this is irrelevant for most amateur photography. An ISO 400 film puts you back on equal ground with the fast 50mm f/1.8 lens in low light. And the sophisticated TTL flash metering of the N70/F70 produces beautiful results, reducing the need to shoot with available light alone. Because today's films are infinitely better than those of five years ago (when the 50mm f/1.8 was still common), we see much less need for such "fast" lenses.

Granted, Nikon could design and build a 70-210mm zoom with a constant f/2 maximum aperture. But the price, size and weight are prohibitive. Even the AF Nikkor 80-200 f/2.8D zoom is considered too large and expensive by most photo enthusiasts. And this is by no means a "fast" lens when compared to those of f/1.4 or f/2 which can still be purchased.

## Variable Aperture Concerns

The variable aperture technology found in the AF Nikkor 70-210mm f/4.5-5.6D offers several benefits. Although the maximum aperture reduces as you zoom toward 210mm, this lens is a bantam weight; it's about half that of the AF 80-200 f/2.8D. Image quality is highly respectable, although the "fast" lens boasts the superior optics of special glass for maximum sharpness.

The AF 70-210mm f/4.5-5.6 (and several others mentioned later) proves that even affordable zoom lenses can produce high image quality. At this price, it won't match the "prime" lenses or "pro" zooms, but will definitely satisfy the vast majority of photo enthusiasts. Besides, the variable aperture may be irrelevant here: it is

the optical formula with special glass which improves the resolution of the expensive zooms.

Some will complain that the variable aperture makes light metering complicated because the aperture size reduces as you shift focal length. This is true when using an accessory (handheld) meter, but not with TTL metering in the N70/F70. Granted, light transmission is reduced as you shift toward longer focal lengths, but exposures remain accurate with or without TTL flash. The system measures the light actually reaching the film no matter what the actual f/stop. The N70/F70 displays the nearest working aperture corresponding to the focal length. Hence, there is no need to compensate for the "shrinking" aperture size as you zoom.

It is tempting to dismiss zoom lenses because of the "disadvantages" already mentioned. And yet, in spite of the complaints we hear, both authors of this guide use such a lens frequently. Some of our most successful photos were made with an AF Nikkor zoom. While we own prime lenses too, neither of us would be willing to give up his zoom lenses.

## Shooting with Zoom Lenses

Earlier we used the term "optical potential". This refers to the fact that even the best lens will produce unsharp pictures unless a few precautions are taken. In a previous chapter we provided some hints for proper holding techniques and the value of a firm support in producing sharp pictures. The use of flash is also helpful, although some zooms will block the light from the flip-up Speedlight. And remember that any lens produces the highest resolution at the mid-range of apertures, usually from f/8 to f/11.

Sometimes there is an overriding need to shoot at f/4.5 or f/22, for depth of field or shutter speed suitable to meet your intentions. Otherwise, try shooting at around f/11 for the sharpest possible results with any zoom lens.

**Hint:** A true disadvantage with zooms is that flare is more of a problem. When shooting into bright light, always use a lens hood intended specifically for that series of focal lengths. In extreme conditions, mount the N70/F70 on a tripod and shade the lens even further with a hat or newspaper. This will prevent stray light

from striking the front element which would degrade image sharpness and contrast. The effects of flare are visible in the viewfinder so you can see when extra precautions are required.

**Varying Perspective**
It's a known fact that varying the focal length can change apparent perspective. A 75mm focal length shows the Grand Canyon in a completely different manner than a 300mm focal length used from the same position. Decide which will most effectively provide the results you desire. Try viewing the scene from several positions: higher, lower, to the left, to the right, and so on. Check the effect produced by several focal lengths and take the picture when the situation looks "best."

At 300mm, a lens does more than just bring distant objects closer. It manipulates distance and compresses perspective, stacking near and distant hills closer to one plane. Exactly the opposite occurs with wide-angle lenses. They "expand" perspective by pushing objects further back and increasing the apparent distance between them.

An extensive discussion of these factors is beyond the scope of this guide. However, we do recommend further study on this topic; photo magazines often include suitable articles. You'll probably want to own at least two zoom lenses, perhaps an AF 24-50mm f/3.3-4.5 and an AF 75-300mm f/4.5-5.6. With these you can cover 90% of the focal lengths used by the majority of advanced amateurs to create dramatic images matching those published in the finest magazines.

# AF Nikkor Zooms

### AF Nikkor 20-35mm f/2.8D
This is the shortest focal length zoom lens for the N70/F70. In a zoom range of only 15mm, it encompasses most of the ultra wide to moderately wide-angle range. Expressed in terms of diagonal angles of view (a typical measurement useful in making lens comparisons) the difference is far more impressive, from a full 94 degrees to 64 degrees.

An aspherical front element counteracts optical aberrations for high sharpness from edge to edge of the frame. And a constant

## Nikkor 20-35mm f/2.8D AF

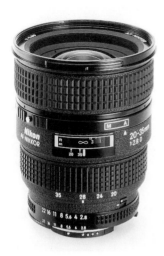

f/2.8 maximum aperture makes it ideal for viewing and shooting in low light. Use the lens hood to prevent flare accentuated by the 14 elements. This professional lens is by no means a featherweight and costs roughly twice as much as your N70/F70 body. It is also somewhat large, accepting 77mm filters. But if you're a photo journalist or serious landscape photographer, you'll definitely save up to own this zoom eventually.

### AF Nikkor 24-50mm f/3.3-4.5

For those who prefer a smaller zoom which accepts standard 62mm filters, this one has become extremely popular thanks to remarkable optical performance. It encompasses the range from very wide to normal focal length in a relatively lightweight package. Its close focusing ability (1.6'/.5m) is available throughout the range, a useful feature especially for wide-angle work.

Like the previous lens mentioned, this is also a "two touch" zoom with two rings: one for adjusting focus and the other for focal lengths. It's a favorite of B. "Moose" Peterson, author of the *Nikon Guide to Wildlife Photography* and *Magic Lantern Guide to Nikon Lenses*, both useful companions to this guide. Optical potential is very high, especially in the f/5.6 to f/8 range of apertures.

**Nikkor 28-70mm f/3,5-4,5 D AF**

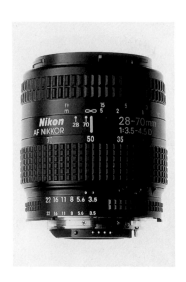

### AF Nikkor 28-70mm f/3.5-4.5D

This zoom lens provides excellent image quality with small physical size, achieved with an aspheric element to combat optical aberrations. This two-ring zoom is an ideal "normal lens" for the N70/F70. At 28mm, the 74 degree angle of view is well into the wide angle range but without the "exaggerated perspective" noticeable with 24mm lenses. At 70mm, it may be a bit short for a portrait lens but fine for photos of couples or small groups.

It is especially useful when using the flip-up Speedlight as the barrel will not block the illumination. The filter diameter of 52mm is common, however, the front element does rotate during focusing so a polarizing filter must be frequently readjusted after each focusing change. Close focusing is continuous (down to 1.3'/0.39m) at all focal lengths for a reproduction ratio of 1:4.6 at 70mm.

### AF Nikkor 28-85mm f/3.5-4.5N

This lens appeared before the 28-70mm D-type Nikkor, so it is heavier and larger due to the extra elements (15 in total) required for comparable optical quality. The extra 15mm of focal length does increase its appeal, however. We find 85mm more useful than 70mm, especially for a "head-and-shoulders" portrait. And it

will focus even closer (down to 0.8') for higher magnification. The "N" denotes that it is a "new" design (in 1992), replacing the older AF model which was not as sharp.

## AF Nikkor 35-70mm f/2.8D

This is a very fast "professional" alternative to other zooms in the normal focal length range and it typifies the problems encountered with "fast" zooms. Size, weight and price increase substantially due to the f/2.8 constant maximum aperture. This was one of the first Nikkors to be upgraded to the D-type, evidence of its popularity especially among photo journalists. The range of 35-70mm is not particularly versatile but is a lot more so than a standard 50mm prime lens, so you can fine tune composition without changing the shooting position.

It takes 15 elements to produce superb image quality for sharpness and contrast, particularly impressive from f/4 to f/11. But they do increase its propensity for flare, so a lens hood should always be used during outdoor shooting. The front element of this two ring push-pull zoom also rotates during focusing, making the use of a polarizer less convenient. Its 62mm filter size is becoming common these days although more expensive than those of 52mm diameter.

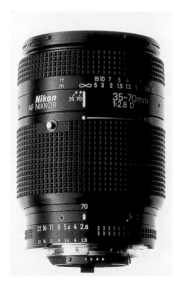

**Nikkor 35-70mm f/2.8D AF**

143

The top image appears to be less sharp and have less contrast because of flare. The definition of flare is non-image-forming light which enters the camera and reflects off the interior surfaces. Flare commonly occurs when the lens is pointed towards a light source. In the bottom photo, a lens shade was added which improved the photo immensely.

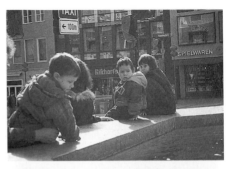

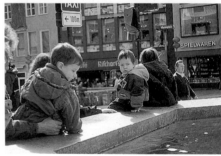

### AF Nikkor 35-80mm f/4-5.6D

One of the more recent Nikkor zooms, this one is a small, light-weight alternative to the f/2.8 model with an extra 10mm of focal length. It's particularly affordable, and will not block flash, making it a fine choice as a "standard lens" for the N70/F70. Remark-able optical performance puts it high on the price/value scale. It is so compact and light (9 oz./255g) that it's an ideal lens for hiking and other outings.

The lens has an aspheric element for improved optical perfor-mance. The downside is a relatively "slow" maximum of aperture f/4-5.6 which is the price paid for its compact design. You can compensate by using one of the superb ISO 200 or 400 print films. Take care in backlight, however, using the optional HN-2 lens hood to reduce flare.

The lens is a turn zoom and can be focused continuously to 1.15'/35cm at all focal lengths. The filter diameter is a standard 52mm, but again the front element rotates during focusing. The

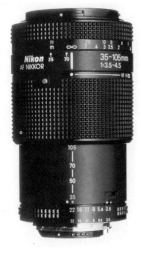
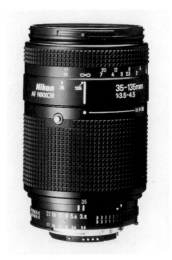

Nikkor 35-105mm f/3.5-4.5 AF        Nikkor 35-135mm f/3.5-4.5 AF

focal length range from moderate wide angle to short tele is well suited to the photographic newcomer, as it produces "normal" perspective, unlike ultra wides and longer lenses.

### AF Nikkor 35-105mm f/3.5-4.5 D

Because 105mm is preferable to 85mm for close-ups of people, this model extends beyond those already surveyed, including many useful focal lengths. It actually overlaps with those in a 70-210mm zoom so you may not want to own both.

An optical formula consisting of 16 elements does make it a bit heavy (16.1 oz./510g) but the barrel is relatively compact, with a 52mm filter size. This push-pull zoom allows focusing down to 1.3'/28cm for a maximum reproduction ratio of 1:3.5. Many nature photographers use it with an extension tube. This is an accessory which reduces close-focusing distance for extreme close-up work with high sharpness/contrast.

### AF Nikkor 35-135mm f/3.5-4.5N

Even more versatile and including most of the portrait focal lengths, this one really deserves its popularity. At 135mm it pro-

duces fine portraits, with extremely pleasing perspective without compressing facial features. This is the minimum focal length required to blur away distracting backgrounds, although the f/4.5 maximum aperture is a bit small for that application.

The optical formula is rather complex, with a full 15 elements. At a weight of 23 oz./685g, with filter size of 62mm, this is not the smallest zoom lens around. Optical performance is highly acceptable but the AF 35-135mm f/3.5-4.5N does not qualify as a professional lens.

### AF Zoom Nikkor 70-210mm f/4-5.6D

A much "sharper" lens, this zoom was recently upgraded, for fine optics and D-type technology for 3D Matrix metering with the N70/F70. This focal length range remains a best seller, and understandably so. It's a fine complement to a shorter zoom such as the AF 28-70mm, covering the next set of focal lengths.

The applications for this telephoto zoom are unlimited, primarily over moderate distances. You can shoot candids from across the room, tripping the shutter at the instant of a fleeting expression. If you have been working with a shorter telephoto, the 210mm focal length will seem impressive. Contrary to popular opinion, it is excellent for landscapes to isolate the most appealing components of a vast scene instead of recording numerous competing elements with a wide-angle lens.

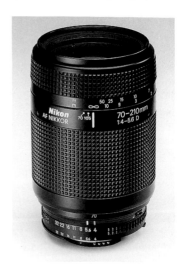

Depth of field is quite shallow at the long end (especially in close-ups) even at f/5.6. Due to this small maximum aperture, you may want to use an ISO 200 or 400 film for high (1/250 sec.) shutter speeds at 210mm in hand-held photography.

At 20.6 oz./590g, the lens is not very light, but you won't leave it on the N70/F70 all the time. It requires 62mm filters

**Nikkor 70-210mm f/4-5.6D AF**

like many other zoom lenses today. This push-pull model focuses down to 4'/1.2m at all focal lengths and produces a maximum reproduction ratio of 1:4.5. Image sharpness/contrast is high at all apertures from f/8 to f/16, even in the corners, which is unusual for a zoom in this price range.

### AF Zoom Nikkor 75-300mm f/4.5-5.6
This longer zoom incorporates several of the most popular telephoto focal lengths and has become a favorite of some professional outdoor photographers. Photo enthusiasts will want this one for amateur sports, auto races and for animals in controlled conditions.

Generally, 300mm is the shortest focal length required for an obvious "compressed" perspective, with cars, poles and pedestrians appearing closer together than the eye perceives. In close focusing especially, depth of field is quite shallow. This increases the ability to emphasize the subject instead of its surroundings.

For the price, optical quality is incredible. Its close focusing ability (5'/1.5m) is also amazing, one of the best in the 300mm range. This push-pull zoom requires 62mm filters, and weighs a full 30 oz./850g. The extra weight can be an advantage in hand-held work, helping to stabilize equipment. This reduces the risk of camera shake slightly, but shoot at 1/500 second by 300mm. A rotating tripod collar is supplied because such high shutter speeds are not frequently available with slow film, except on sunny days. You may get by at 1/125 second if bracing your elbows on something rigid, but that will not guarantee the sharpest results.

### AF Nikkor 80-200 f/2.8D ED
This is a personal favorite in the Nikkor line, as it's a zoom capable of pro-caliber sharpness at any aperture. Although expensive, it is not entirely out of reach of the photo enthusiast. In fact, many advanced amateurs own this lens or an earlier model.

Three ED (extra low dispersion) glass elements make it one of the "sharpest" zooms in the world, with excellent color fidelity and freedom from optical distortion. This precaution is most important with telephoto lenses of wide aperture, such as f/2.8, constant at all focal lengths with this zoom.

At f/2.8, depth of field is so shallow that important details can be isolated completely through selective focus. The background becomes a soft blur, especially when shooting close-ups.

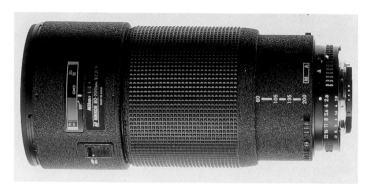

**Nikkor 80-200mm f/2.8D AF ED-IF**

All this was achieved with some technical complexity: 16 elements, plus substantial weight (42.3 oz./1.3 kg.) and a 77mm filter size. With the D-type model the front lens element does not rotate during focusing. Frankly, some will find its weight (about twice that of the N70/F70) excessive, particularly after carrying it any great distance.

Because it's intended for hand-held shooting, this push-pull zoom lacks a tripod mounting collar. Check the ads in photo magazines for a suitable accessory as Nikon does not offer one. Nonetheless, this is one zoom worth saving up for, as it will bridge the gap between amateur and professional, at least in terms of technical quality.

## Wide-Angle "Prime" AF Nikkors

Modern zoom lenses are forcing single focal length (prime) lenses into the role of the specialist, often with wide maximum apertures and ultra wide angles of view.

The shortest AF Nikkor is the 16mm f/2.8D Fisheye, with a coverage of 180 degrees. Use care not to include your feet, or tripod legs, in the frame when shooting with such lenses. This is a full-frame fisheye, unlike some which produce a circular image in the center of the film. Extreme barrel distortion creates a curving of all straight lines except those which run through the center of

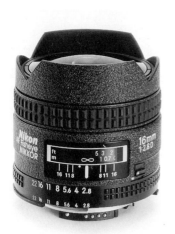

**Nikkor 16mm f/2.8D AF;
Full-frame Fisheye Lens**

the frame. This curvature becomes stronger towards the edges of the frame, a common characteristic of such lenses.

**Hint:** Finding suitable subjects for a 16mm lens is difficult. Try shooting landscapes without distinct lines (such as trees) moving in very close to some foreground element. This is necessary because of a tendency to push everything far back optically. Or point it upwards among a huddle of football players or some flowers. Try using it indoors to record cramped interiors as spacious.

Depth of field is incredibly vast even at wide apertures, making critical focus (even in AF) difficult. That's often academic since most everything in the photo will appear sharp due to depth of field. Frankly, few photographers can justify the price of this lens and fewer still can exploit its unique perspective.

### Ultra Wide AF Nikkors

The ultra wide-angle range starts with AF Nikkor 18mm f/2.8D. This lens records an "undistorted" diagonal angle of view of 100 degrees with straight line rendition. Some "perspective distortion" is still apparent in an image made with any 18mm lens (round objects in the corners of the image are rendered elongated). This occurs simply as a result of the extreme angle of view and is not due to poor optical correction.

**Nikkor 20mm f/2.8D AF**

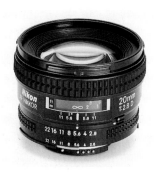

The photo enthusiast will probably prefer the AF 20mm f/2.8D with its less extreme price and angle of view. This one covers 94 degrees, still keeping it in the ultra wide category with "expanded spatial perspective". Nearby subjects loom in the viewfinder while those further back appear to recede dramatically. This tendency calls for some expertise to produce dramatic pictures. Look for a dominant foreground element because more distant objects will become mere specks in the frame. With Nikon's CRC (Close Range Correction) used to correct for optical aberrations, image quality will be excellent.

**Hint:** With any ultra wide-angle lens, keep the camera level to minimize "linear distortion" (explained in a moment). Unless aiming for an impressionistic look, this is best achieved by mounting the N70/F70 on a tripod with an accessory bubble level (like one from HAMA). Shooting from a low vantage point will help produce the most dramatic photos. Practice, experiment and shoot various types of subject matter until you master the wide-angle perspective.

Don't limit the potential of your telephoto lenses; they aren't only useful for shooting sports and wildlife. Try using them to photograph architectural details. Tilt the camera up and capture a unique and interesting view of a skyscraper.

**Wide-Angle AF Nikkor Lenses**

The standard wide-angle range starts with the AF Nikkor 24mm f/2.8D with its 84 degree angle of view still likely to produce marked "converging" lines. If you tilt the camera upward, for example, vertical lines will appear to converge while buildings will seem to lean backwards.

This "linear distortion" is most noticeable with focal lengths of 24mm and shorter. With some skill, you can minimize the effect or exaggerate it intentionally, when shooting upward in a stand of trees or skyscrapers in a city. With this AF Nikkor, sharpness will be excellent from edge to edge due to CRC, even in close focus photography.

A 24mm lens can be used more often than a 20mm because the apparent distortion of perspective is not as noticeable. We consider this AF Nikkor (or a zoom including 24mm) a fine starting point for exploring wide-angle effects. After mastering a 28mm focal length, try 24mm if you appreciate the creative potential.

Nikon offers several options in the moderately wide-angle range of prime lenses, with the AF Nikkor 28mm f/2.8 D the most affordable. The AF Nikkor 28mm f/1.4 D is intended for professionals who can justify its price while taking advantage of the wide aperture, as in photo journalism. The AF 35mm f/2 is compact, reasonably priced and optically excellent. However, this focal length is more often purchased in a zoom lens.

## "Normal" Lenses

The 50mm lens is considered normal in 35mm photography because it produces a "natural" perspective. The picture looks very much like we saw the scene with our own eyes. There's no optical trickery here. On the other hand, a 50mm lens tends to produce "average" pictures in most hands. Used as a tool by the creative photographer, it can produce impressive results in spite of its unpretentious fixed focal length.

The AF Nikkor 50mm f/1.8 is quite inexpensive because the optical corrections required for fine quality are minimal. Such a "fast" lens can save the day in low light conditions or indoors when flash is not appropriate or is not allowed.

Nikon also offers the AF Nikkor 50mm f/1.4 which is a half stop

"faster", that is, the maximum aperture is wider. For that advantage you'll pay about three times as much because of the optical complexity. Think twice before spending the extra money. A 50mm f/1.8 is the fastest lens most of us will ever need and the AF Nikkor model is light, compact and optically excellent.

## Short to Medium Telephotos

The 85mm lens is considered as a short telephoto in the 35mm format. Its angle of view (28 degrees) is noticeably narrower than that of the normal lens' 46 degrees. And wide maximum apertures can still be found in this focal length, useful for selective focus. You can fill the frame with a "head-and-shoulders" portrait without moving too close. This greater working distance is appreciated by the subject but there's another benefit. There is little apparent distortion of the subject's nose as is common with shorter focal lengths used for close-ups.

Naturally, an 85mm lens like the AF 85mm f/1.8D has other applications. Some use it as their "standard" lens for a variety of subject matter with tight composition. This is a suitable choice as a fast second lens for the owner of a "slow" zoom of f/3.5 or f/4.5. Its weight is tolerable (15 oz./415 g.), the price manageable, AF speed incredible, and image quality remarkable.

**Nikkor 85mm f/1.8D AF**

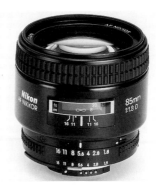

Moving up to 105mm and 135mm, we cross into the true telephoto range. The AF Nikkor line confirms that prime lenses of this

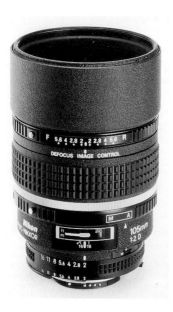

**Nikkor 105mm f/2 DC AF**
Features Nikon Defocus Image Control for selective control of background and foreground blur.

focal length are intended for the specialist. The AF DC Nikkor 105mm f/2 D and AF DC Nikkor 135mm f/2D incorporate "defocus control". This unique feature allows you to control which picture elements will be defocused and to what extent. You can fine tune the level of sharpness in the foreground or background at any aperture, creating unique effects especially in portraiture.

Do not confuse defocus lenses with "soft focus" diffusion accessories. Image sharpness is excellent with the DC duo, but distractions can be blurred away. Extra blades in the aperture design create a more circular opening which produces round blobs of defocused color.

Using defocus control requires creative experimentation as the effect cannot be judged in the viewfinder. Try shooting a series of pictures, adjusting the DC ring to throw unwanted elements out of focus, even at small apertures such as f/11. Then set fine focus manually or with AF. Both these fast (expensive) lenses are also well-suited to general photography but are best used by the photographer who demands the ultimate in defocus control.

# ED-IF Technology

Now we reach the cream of the AF Nikkor crop, the professional telephotos. All of these share two characteristics: internal focusing (IF) and elements of Extra-low Dispersion (ED) glass to correct chromatic aberrations. Without getting technical here, let's explain the process as follows. By forcing all wavelengths of light to focus on a common point (the film plane), ED glass produces images of superb quality: razor sharp, without color fringing, and with high contrast for an impression of extreme sharpness.

With IF, only a few optical elements are moved during focusing. This is preferable to moving the entire (heavy) optical system which would shift the weight of the lens. With an IF system, both the center of gravity and physical length of the barrel remain constant, a benefit with long lenses. The lens/camera combination is more stable on a tripod while the barrel can be made more compact. This type of construction makes close focus correction easier too, assuring superior results at any distance. As a bonus, IF improves autofocus speed, as less mass must be moved by the AF drive motor.

Nikon's ED glass has become a legend in its own time. All ED telephotos provide extraordinary quality by compensating for chromatic aberration as described earlier. This measure is necessary in lenses of long focal length, especially those of wide maximum aperture, to meet professional standards of optical quality.

## The Nikkor ED-IF Line

The AF 180mm f/2.8 ED-IF is a lens of traditional focal length becoming less popular as zoom lenses dominate the market. The advantage of this prime lens over the AF 80-200 f/2.8 D ED is size. It's much smaller and lighter (25 oz./750g.) and handles beautifully. It is much easier to hand-hold at shutter speeds of 1/200 second (which can be selected on the N70/F70) for crisp results with the N70/F70. Fashion photographers especially still swear by this 180mm prime lens, whose price is not beyond reason.

Nikon offers three options in the prime 300mm AF line: the AF Nikkor 300mm f/2.8N ED-IF, the new AF-I 300mm f/2.8 D ED-IF (with integral focus drive motor) and the AF Nikkor 300mm f/4 ED-IF. One glance at the price list will tell you that the first two are primarily for pros, who need an ultra wide aperture at this focal length for action photography with slow film.

However, the f/4 model (still "fast" when compared to zooms) will appeal to the photo enthusiast as well, due its moderate price. Because of its relatively low weight (46.6 oz./1330g.) this one remains quite portable and hand-holdable. However, unless shooting with ISO 400 film or in bright light consider using a monopod. The lens will attach directly to that support accessory with its built-in tripod mounting collar. Like all ED telephotos it has a rear filter drawer which accepts small (inexpensive) 39mm filters. These are replaced in a holder at the far end of the light path.

All three AF 300mm Nikkor lenses produce outstanding image quality at any aperture and at any distance. All produce a noticeable compression of elements an unavoidable characteristic of longer focal lengths. In many cases, however, this is perfectly suited to creative intentions. Such a lens is designed not only for distant subjects but also for shorter ranges where the shallow depth of field is desirable.

The longer AF Nikkor lenses are specifically intended for the working professional at a price you might pay for a compact car. Hence, we will not describe those in this book. The *Magic Lantern Guide to Nikon Lenses* is but one good source of information on the AF-I 400mm f/2.8 D ED-IF, AF-I 500mm f/4 D ED-IF, and the AF-I 600mm f/4 D ED-IF.

## Extreme Close-up Photography

As a single lens reflex (SLR) camera, the N70/F70 is well suited to extreme close-up photography. Because the viewfinder image is without parallax error, the framing will be accurate. What you see is what you'll get on film, except for the fact that the N70/F70 viewfinder only shows 92% of the actual image area. (This was discussed in the Chapter – *A New Operating Concept*).

Most photo enthusiasts see the world only in terms of larger scales, but extreme close-up photography can open up another dimension. We literally have to learn to see things in smaller portions instead of ignoring tiny details. The search for suitable subjects is made easier when an AF Micro-Nikkor lens or close-focus accessory is mounted. With the higher magnification, thousands of potential subjects are just waiting to be explored, whether natural or man made.

**Use a Micro-Nikkor lens, such as the 60mm f/2.8D AF Micro, to magnify very small objects. This postage stamp was photographed at approximately a 1:1 ratio, meaning it is life-size on the film.**

Extreme close-ups, usually referred to as "macro", are most often used for two subjects: those found in nature and tiny objects such as stamps in a collection. In macro photography we do not concentrate on microscopic-sized objects. A flower, small insect and a coin are typical subjects for macro photography. A dragon fly covered with dew and clinging to the stem of a weed or the pistil and stamen of a tulip are but two popular examples frequently seen in books and magazines.

***Note:*** Some AF Nikkor zoom lenses offer a "macro" capability. This is not true macro at all but a close focusing ability which will reproduce the subject at up to 1/4 life-size: the 1:4 reproduction ratio mentioned earlier. The term "macro" once denoted a lifesize (or 1:1) reproduction ratio. Today the definition is broader including 1/2 lifesize (1:2 ratio), easily achieved with AF Micro-Nikkor lenses and other lenses with certain accessories.

**The Next Step**

You can start recording small details with one of the AF Nikkor zooms, which are useful for isolating details such as a large blossom in a garden. However, you will eventually recognize a need to focus much closer. This can be achieved inexpensively with a Nikon accessory close-up lens. Resembling a clear filter containing magnifying glass, this device is small, portable and absorbs no light. AF ability is maintained but you'll want to focus manually in order to set the exact point of focus. This is critical as depth of field is extremely shallow in high magnification work.

Infinity focus is lost because, in effect, you are putting reading glasses on your Nikkor lens. That's merely academic, of course, as the subject will be mere inches from the front element. The close focusing distance is reduced depending on the "power" of the accessory lens. These are available from Nikon as 1 and 2, and as 3T, 4T, 5T, and 6T versions. The first two are for lenses up to 55mm, while the T-series works best with focal lengths in the 75mm to 300mm range.

The T-Series is made with two elements (instead of one) and is "achromatic": corrected for optical aberration. The 3T/4T come in a 52mm filter ring, while the 5T/6T in a 62mm ring; otherwise they are identical (you can buy step down rings to use these with lenses of smaller diameter). In either case, the higher number denotes a stronger effect. Although there are more sophisticated means of achieving extreme close focus, the Nikon T-Series is used even by professional nature photographers. Optical quality is first rate, especially when used with a Nikkor tele lens such as the AF 75-300mm f/4.5-5.6. Stop down to f/16 or f/22 for optimum image sharpness from the center to the corners of the frame.

**Extension Tubes**

You can use extension tubes instead to reduce a lens' close focusing distance. These are spacers which fit between the camera and the lens' mount - hollow tubes which move the optical center further from the film plane. This allows closer focusing. As of this writing, Nikon offers only Auto extension tubes and not AF extension tubes. The current type maintains some N70/F70 functions, the same as when using the camera with a manual focus Nikkor lens (described in an earlier section).

However, some capabilities are lost, especially Matrix meter-

ing, autofocus, Program modes, etc. More importantly, any extension produces a light loss; a darker viewing screen and longer shutter speeds result. Fortunately, the TTL metering system (Center-Weighted) continues to function as do Aperture Priority and Manual modes. This combination allows for excellent macro photos to be made with the N70/F70 using these affordable accessories. Optical quality (with most lenses) remains highly acceptable at f/11 to f/16 especially (check the Instruction manual for each AF Nikkor lens as to non-compatibility with certain models of Auto Extension tubes).

## Macro or "Micro" Lenses

Anyone who becomes a close-up photo enthusiast will eventually consider a true macro lens, called "Micro" by Nikon for reasons which remain a mystery. These are all optimized for extremely close focus, producing superior results than others used with accessories. Close Range Correction (CRC) is employed so each provides superb edge to edge sharpness from infinity to its closest focusing distance. In fact, the Micro Nikkor lenses are among the sharpest in the world, outperforming most others of any type.

All offer continuous focusing to any distance down to a reproduction ratio of 1:1. Also called "life-size", this means that a honey bee will be exactly honey bee-sized on a 35mm slide or negative. To achieve this, Nikon employs both mechanical and optical strategies to move the optical center further from the film plane. In the optical formula, individual elements are moved in opposite directions during focusing. This strategy minimizes the light loss resulting from extension.

## D-Type Micro Nikkor Lenses

Three AF Micro Nikkor lenses include the Distance Signal chip for full 3D Matrix metering with the N70/F70. The first is the AF Micro Nikkor 60mm f/2.8 D suitable for use as a macro lens or as a high quality "normal" lens. This is the lens of choice for reproduction work where the camera is generally mounted on a copy stand fairly close to an inanimate object.

The AF Micro Nikkor 105mm f/2.8 D can be considered a universal telephoto lens with particularly high image quality (and continuous focusing down to 1:1, of course). Since the working distance increases with focal length, you can fill the frame with a

## AF Nikkor Lenses for the N70/F70

| | Elements/ Groups | Diagonal angle of view | Min. Aperture | Close foc distance ( |
|---|---|---|---|---|
| **Zoom Lenses** | | | | |
| 20-35mm f/2.8 D | 14/11 | 94°-62° | 22 | 1.7 |
| 24-50mm f/3.3-4.5 | 9/9 | 84°-46° | 22 | 2 |
| 28-70mm f/3.5-4.5 D | 8/7 | 74°-34°20′ | 22 | 2 |
| 28-85mm f/3.5-4.5 | 15/11 | 74°-28°30′ | 22 | 3 |
| 35-70mm f/2.8 D | 15/12 | 62°-34°20′ | 22 | 2 |
| 35-80mm f/4-5.6 D | 6/6 | 62°-30°10′ | 22 | 2 |
| 35-105mm f/3.5-4.5 | 16/12 | 62°-23°20′ | 22 | 5 |
| 35-135mm f/3.5-4.5 | 15/12 | 62°-18° | 22 | 5 |
| 70-210mm f/4-5.6 D | 12/9 | 34°20′-11°50′ | 32 | 5 |
| 75-300mm f/4.5-5.6 | 13/11 | 31°40′-8°10′ | 32 | 10 |
| 80-200mm f/2.8 D ED | 16/11 | 30°10′-12°20′ | 22 | 6 |
| **Fixed Focal Length Lenses** | | | | |
| FE 16mm f/2.8 D | 8/5 | 180° | 22 | 0.85 |
| 18mm f/2.8 D | 13/10 | 100° | 22 | 0.85 |
| 20mm f/2.8 | 12/9 | 94° | 22 | 0.85 |
| 24mm f/2.8 D | 9/9 | 84° | 22 | 1.25 |
| 28mm f/1.4 D | 11/8 | 74° | 16 | 1.3 |
| 28mm f/2.8 | 5/5 | 74° | 22 | 1.25 |
| 35mm f/2 | 6/5 | 62° | 22 | 0.85 |
| 50mm f/1.4 | 7/6 | 46° | 16 | 1.5 |
| 50mm f/1.8 | 6/5 | 46° | 22 | 1.5 |
| 85mm f/1.8 D | 6/6 | 28°30′ | 16 | 3 |
| DC 105mm f/2 D | 6/6 | 23° | 16 | 3 |
| 180mm f/2.8 IF-ED | 8/6 | 13°40′ | 22 | 5 |
| 300mm f/2.8 IF-ED | 8/6 | 8°10′ | 22 | 10 |
| AF-I 300mm f/2.8 D IF-ED | 9/11 | 8°10′ | 22 | 10 |
| 300mm f/4 IF-ED | 8/6 | 8°10′ | 32 | 9 |
| AF-I 400mm f/2.8 D IF-ED | 7/10 | 6°10′ | 22 | 15 |
| AF-I 500mm f/4 D IF-ED | 9/7 | 5° | 22 | 18 |
| AF-I 600mm f/4 D IF-ED | 9/7 | 4°10′ | 22 | 20 |
| **Macro Lenses** | | | | |
| 60mm f/2.8 D | 8/7 | 39°40′ | 32 | 0.815 |
| 105mm f/2.8 D | 9/8 | 23°20′ | 32 | 1 |
| 200mm f/4 D IF-ED | 13/8 | 12°20′ | 32 | 2 |

| Macro ng (ft) | Filter diameter (mm) | Lens hood | Length (inches) | Max. diameter (inches) | Weight (g/oz.) |
|---|---|---|---|---|---|
| | | | | | |
| | 77 | HB-8 | 3.7 | 3.2 | 640/22.4 |
| | 62 | HB-3 | 2.9 | 2.8 | 375/13.1 |
| | 52 | HB-6 | 2.8 | 2.7 | 355/12.4 |
| | 62 | HB-1 | 3.5 | 2.8 | 540/18.9 |
| | 62 | HB-1 | 3.7 | 2.8 | 675/23.6 |
| | 52 | HN-2 | 2.4 | 2.6 | 255/8.9 |
| | 52 | HB-5 | 3.4 | 2.8 | 510/17.9 |
| | 62 | HB-1 | 4.3 | 2.9 | 685/24.0 |
| | 62 | HN-24 | 4.3 | 2.9 | 590/20.7 |
| | 62 | HN-24 | 6.5 | 2.8 | 850/29.8 |
| | 77 | HB-7 | 7.4 | 3.4 | 1300/45.5 |
| | | | | | |
| | Bayonet | Built-in | 2.2 | 2.5 | 285/10.0 |
| | 77 | | 2.2 | 3.2 | 385/13.4 |
| | 62 | HB-4 | 1.7 | 2.7 | 260/9.1 |
| | 52 | HN-1 | 1.8 | 2.5 | 260/9.1 |
| | 72 | HK-7 | 3.1 | 3.0 | 520/18.2 |
| | 52 | HN-2 | 1.5 | 2.5 | 195/6.8 |
| | 52 | HN-3 | 1.7 | 2.5 | 215/7.5 |
| | 52 | HR-2 | 1.7 | 2.5 | 255/8.9 |
| | 52 | HR-2 | 1.5 | 2.5 | 156/5.5 |
| | 62 | HN-23 | 2.3 | 2.8 | 415/14.5 |
| | 72 | Built-in | 4.1 | 3.1 | 620/21.7 |
| | 72 | Built-in | 5.7 | 3.1 | 750/26.2 |
| | Bayonet | Built-in | 9.5 | 4.9 | 2700/94.5 |
| | 39mm Rear | Built-in | 9.5 | 4.8 | 2700/102.4 |
| | Bayonet | Built-in | 8.6 | 3.5 | 1330/46.6 |
| | 52mm Rear | Built-in | 15.2 | 6.4 | 3300/180.3 |
| | | Built-in | | | |
| | 39mm Rear | Built-in | 16.4 | 6.5 | 6050/212.8 |
| | | | | | |
| | 62 | HN-22 | 2.9 | 2.8 | 455/15.9 |
| | 52 | HS-7 | 3.3 | 2.6 | 555/19.4 |
| | 62 | | 7.6 | 3.0 | 1200/42.0 |

butterfly without moving right up to the insect. This one will produce a full life-size image form 1.34' away instead of a mere 9".

The longer Micro lenses are more suitable for nature photography with less risk of scaring a live subject. The extra distance also provides a bit of security, particularly if the subject is inclined to bite or sting. And the longer focal length allows you to isolate the subject, excluding much of a distracting background.

Particularly useful in this respect is the new AF Micro Nikkor 200mm f/4D IF-ED. It's not exactly cheap but includes an internal focus mechanism which improves handling and balance on a tripod (due to its greater size and weight, a tripod mounting collar is provided). ED glass was incorporated into this lens to compensate chromatic aberration. The resulting images are razor sharp, with full color fidelity and high contrast. The Micro Nikkor AF 200mm f/4D ED-IF is an excellent all-purpose telephoto lens for outdoor photography, though it is a bit hefty for carrying long distances.

## Specialty Lenses

We will touch only briefly on a few highly specialized Nikkor lenses which are manual focus models. As such, they are not 100% compatible with the N70/F70, as previously described, but maintain enough functions to be useful in serious photography.

First are the two Perspective Control or PC lenses. The lens barrel can be "shifted" off its axis, both up and down. This feature can be used to prevent converging lines which would occur if the N70/F70 were pointed upwards at tall buildings, for example. The camera back can now be kept parallel to the subject, while including the entire building. This precaution prevents distortion of vertical lines (or horizontal lines if the N70/F70 is used in the vertical format). The PC lenses are especially useful in architectural photography.

**For photographing architecture with an N70/F70, Nikon makes Perspective Control (PC) lenses. These lenses provide an off-axis shift to reduce the convergence of parallel lines which make vertical structures appear to be leaning.**

Both the PC Nikkor 28mm f/3.5 and the PC 35mm f/2.8 are constructed without automatic aperture linkage. After taking the meter reading and focusing, you must manually shift down to the shooting aperture on the main ring and a secondary ring for correct exposure. These lenses are heavy and slow in operation but are invaluable for those who require such optics.

Another fascinating lens is the Nikkor 500mm f/8N, a mirror or "catadioptric" telephoto. Because the light path is "folded", its length is very short, only 3.5" (116mm). This is made possible by a combination of mirrors and lenses that bend the light and send it back and forth several times within the barrel.

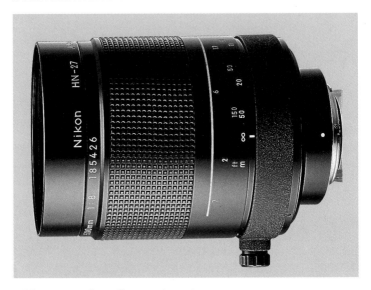

**Nikkor 500mm f/8 Reflex (or Mirror) lens**

Optical quality is outstanding because all chromatic aberration is eliminated. As with all mirror lenses, out of focus highlights are rendered as donut-shaped, a telltale sign that such a lens was used. You can easily hand-hold this highly portable barrel (29.7 oz.) at 1/1000 sec. or faster, and it will fit nicely into your camera bag. Its massive tripod socket lets you know that a firm support should be used for maximum sharpness.

This affordable Nikkor even focuses down to a mere 5', incredible for a 500mm lens. Mirror lenses have a fixed aperture; no adjustment is possible so exposure is controlled only with shutter speed in Aperture-Priority mode. At f/8, this lens is quite "slow", so use an ISO 400, 800 or 1000 film for faster shutter speeds. Nikon also offers a 1000mm and 2000mm mirror lens, but these are priced way beyond the reach of most amateur photographers.

## Nikon Filters

The fact that Nikon offers a wide assortment of filters for their Nikkor lenses is understandable. After all, why produce superior optics when image quality will be degraded by a cheap piece of glass placed in the light path? The principle of the "weakest link" holds true here: any optical system is only as good as the filter used. While it is tempting to buy off-brand filters at bargain basement prices, it makes little sense. Once you decide to travel the path of high image quality, don't allow roadblocks to deter you from reaching that goal.

There are other brands of excellent filters, too, including Tiffen, Hoya multi-coated, B+W, Singh Ray, etc. but we'll concentrate on the Nikon brand. First is the UV filter (L37C) which helps block ultraviolet light to prevent a blue cast. This one is almost clear so it does not absorb any light or produce a color shift. It's also useful for protecting the front lens element from fingerprints or scratches. You can safely clean a filter more often than the sensitive front element of an expensive lens.

Naturally, any filter adds two more air-to-glass surfaces. This increases the risk of flare in bright conditions. When using a multi-coated Nikon filter this is less of a concern, but purists will not leave a filter on their lenses at all times.

**Hint:** Consider the following compromise: use the UV filter when protection is necessary, such as in dusty conditions. But remove it when shooting in brilliant light from the side or behind the subject. When flare becomes visible in the viewfinder (as a light veil reducing sharpness), remove the filter immediately.

Nikon's L1BC Skylight filter is similar to the UV model. It, too, absorbs UV radiation; it's also multi-coated for superior light transmission and reduced flare. Because the Skylight filter produces a slight red color shift, it's more useful for counteracting a mild blue color cast in shade with slide film. However, it is less suitable as a universal filter, as it may add an unwanted color cast to a subject.

**The Polarizing Filter**
There is one filter which everyone should own for outdoor photography. It's the polarizer, used primarily for two purposes: to darken a pale blue sky and to remove reflections from glass or water surfaces.

Mount one on your lens and you'll notice it can be rotated within the filter ring. Its position determines the effectiveness of the polarizer. At approximately 90 degrees (right angle) to the sun or 35 degrees to a reflective subject, the effect is greatest, easily visible in the viewfinder. A polarizer is practically useless when shooting toward the sun but highly effective in sidelighting.

This filter is also useful to wipe glare from water, wet foliage, rocks or any non-metallic surface like a window pane. Color saturation is increased while affording a clearer view of the subject. The effect is particularly noticeable in sunshine. A blue sky becomes richly dark, with white clouds standing out in bold relief due to increased tonal contrast. Many pleasing travel photos owe their high level of appeal to a polarizer.

The effect can be controlled precisely through rotation. If you can't achieve the desired effect, change your shooting angle. While it is tempting to strive for maximum polarization, a more subtle effect is sometimes preferable. With water for instance, removing all the natural sparkle produces an artificial, lifeless look.

Surprisingly, the polarizer reduces overall scene contrast, evening out the exposure; now the film can handle high contrast situations more easily. Polarizers are often the only way to make objects behind glass clearly visible. You may decide to eliminate all reflections or to leave some, depending on the end use of the photo.

*Note:* To maintain metering and autofocus accuracy, the N70/F70 requires a "circular" polarizer. This term is not used to describe the shape of the filter but to differentiate it from the conventional "linear" polarizer. If you own only the latter, do not use it with this camera. Use only polarizers designated CIR for reliable camera operation.

**Use a polarizing filter to darken the sky in a photograph and make clouds stand out. It will also minimize distracting reflections on water.**

While the polarizer is highly versatile, it does have one drawback. The gray glass absorbs roughly 1.5 stops of light. So if you were shooting at 1/125 sec. before adding the filter, this will reduce to 1/45 sec. when the polarizer is mounted. You might open up the aperture to get a faster shutter speed, if that's possible (you may already be shooting at the widest aperture). In other cases, the reduced depth of field may no longer be enough to render the entire subject adequately sharp. This will increase shutter speeds so use a firm support or switch to a film of higher ISO.

**Hint:** In spite of the reduced light transmission, the N70/F70 will maintain metering accuracy with a polarizer. Some books and magazine articles claim that exposure compensation is necessary when filters are used (+1.5 stops with a polarizer, for example). Ignore routine warnings of this type. For all practical purposes, they apply to external exposure meters and are not relevant when using a camera with through-the-lens metering.

# Great Pictures with Your N70/F70

With the sophisticated N70/F70, most anyone can produce sharply-focused pictures with correct exposure. Autofocus, Matrix metering, the high-tech Speedlight, and Program modes make it easy to get technically perfect pictures. This is an impressive achievement except for one fact: a technically perfect picture may have little viewer appeal.

The finest sable brush, the most expensive canvas and the most brilliant paints won't make you an "old master". You will have to develop a feel for the brush strokes, the play of light and shadow, the use of perspective and relative size, etc. More importantly, you'll need an appreciation for the difference between the "real world" image your eyes perceive and that which can be recorded as a two-dimensional photograph.

Photographers use dozens of techniques for creating pictures with high visual appeal, but the following offer good starting points for anyone ready to progress beyond snapshooting.

## Develop an Awareness for Light

Too many people strolling around with a camera find everything photogenic. Sure it's high noon and the light is harsh, but they keep snapping away until the film runs out. What they fail to notice is the direction of the light in relation to the subject. And yet, this factor determines the impact the subject will make on a subsequent viewer.

If the sun is high above, the light will be unflattering for just about any subject. If it is behind your back, the subject receives flat frontal light. Shadows fall behind it, sometimes becoming invisible in the picture. Colors may be bright in such light and the negative easy to print because of low contrast, but the picture may lack an important dimension.

When the sun is to the side, shadows become more readily visible. The interplay between light and shadow (contrast) can help simulate depth in a two-dimensional image. Viewers can easily

identify the foreground and background. The subject becomes contoured instead appearing as a flat, "cardboard cutout" masquerading as three-dimensional object. Texture is also enhanced by side light which illuminates a surface's high points and leaves shadows in the low points, simulating a tactile feel. So try to exploit side lighting when possible to add a three dimensional feel to your pictures.

Back lighting can make exposure metering more difficult but can create magic. Fortunately, the N70/F70's Silhouette Vari-Program is designed to produce well-exposed pictures in precisely these conditions. You may also need to shade the lens to prevent flare, but this is worth the effort. The mood of the image will be far more striking than in front lighting. Large dark areas will bring tranquillity into the picture. Dust, mist or smoke in the atmosphere will create a wonderfully appealing mood when shafts of light become readily visible. Light passes thorough semi-transparent forms such as foliage, producing a glowing shimmer in autumn, for example. The contrast between light and dark areas becomes very high and dramatic. If the contrast is excessive, use flash with the N70/F70.

Unless you're shooting land or cityscapes, it's often possible to move the subject to a better location. Change your own position when that's feasible. Or wait until later in the day when the low sun creates warm side or back light which will enhance the subject. This is all part of controlling the process introduced in earlier chapters. It's another step to creating images instead of merely recording pictures on light-sensitive material.

## Fill the Frame

"If your pictures aren't good enough, you're not close enough". Wise words from WW II photojournalist Robert Capa and probably the best advice we have heard. If you cannot walk up to the subject, switch to a longer focal length. When the situation presents vertical lines, rotate the camera to avoid wasted space at the edges of the frame. Otherwise ask the lab to crop excess space or use a pair of scissors yourself afterwards. If framing the picture, order a custom-cut mat with an opening just the right size to show only the important section of the print.

Naturally, not every situation benefits from tight framing. A photo essay of a blacksmith, for example, calls for including the tools of his trade. A triathlon cyclist needs space to move into but there's rarely any compelling need to include the cars parked along the road beside her.

Strive to present a clear message to the viewer by excluding any superfluous elements. Simplify your pictures from a high or low viewpoint if necessary. No matter what type of photography you enjoy, greater reliance on close-ups should help to increase the visual appeal of your pictures.

## Try New Focal Lengths

While a few photographers have produced an exceptional body of work with a limited range of focal lengths, the majority demand greater versatility. If you have been shooting with the AF 35-80mm Nikkor zoom, for example, consider the possibilities of a 28mm wide angle as a start.

Notice how the foreground becomes more prominent while distant objects are recorded smaller, assuming secondary importance. Move in close to emphasize a group of wildflowers and include an expansive sweep of blossoms behind it. With short focal lengths, depth of field is extensive at most apertures. Set focus roughly a third of the way into a vast scene to render foreground, mid-ground and background in acceptably sharp focus.

Or switch to the AF Nikkor 75-300mm AF Nikkor and zoom out to 300mm. At a zoo, make impressive portraits of the animals instead of duplicating the snapshots of others armed with only a 50mm lens. Capture the intensity of a high school quarterback's expression from the sideline. Or use the narrow angle of view to eliminate a dull sky or irrelevant objects which would compete for viewer attention.

Take advantage of shallow depth of field, rendering one or two blossoms sharply against a soft, poster-like backdrop of an identical color. Again, the possibilities are endless, limited only by your imagination and choice of subject matter.

**Learn to observe light in order to photograph a location at its most flattering. Look for sun skimming across a building to create shadows and highlight architectural details.**

## Select the Best Viewpoint

Frankly, most hobby photographers pay too little attention to camera position and angle to the subject. They notice something of interest and fire from wherever they happen to be standing at the moment.

Shooting from eye level is certainly comfortable. But if every picture is taken from the same height, monotony soon sets in when viewing a slide show or album. Especially with very tall or short people, the results can be less than flattering. In outdoor photography, burn some calories to find different viewpoints. Climb a tree or rock or get down and dirty until you find the best vantage point for the leaves swirling in a stream, and for the direction of the light.

Look for dynamic diagonals, often determined exclusively by your camera position. Instead of facing the store fronts in a Western town, create a diagonal composition by shooting from another angle. When working with short focal lengths, try pointing the camera upward among a stand of trees. Shoot from ground level to make vertical lines converge and become diagonals. Exaggerate perspective intentionally. In both cases, this technique will help add a feeling of depth to the image, to simulate that missing third dimension.

## Strive for Visual Impact

Watch someone browsing through a book full of pictures and one fact will soon become apparent. Today's viewer is quick to evaluate the impact of an illustration, flipping past those which fail to capture his attention. Unless it evokes some emotion or offers a powerful visual statement, it will hold his interest for only a few seconds.

After achieving technical excellence with your N70/F70, challenge yourself to control the situation. Emphasize dramatic skies by placing the horizon lower in the frame. Look for a lead-in line, the rhythm of repetitive elements, the harmony of a graceful curve, or contrasting color or texture.

**The "rule-of-thirds" was followed by the photographer when deciding where to place the bell, the bell pull and the roofline of the church.**

In terms of exposure, do not assume that accurate results will always be the most pleasing. Overexpose intentionally to produce a high key (predominantly light) portrait of a blonde model in white against a white backdrop. Underexpose to produce a silhouette accented by rim lighting, or a low-key (predominantly dark) exposure of a motorcyclist in leather leaning against a black wall. Remember Nikon's comments about Matrix metering: "Your creativity is always the final and deciding factor".

Challenge yourself to get inside the picture to add an intriguing dimension. Photograph children at their own eye level, tripping the shutter at the instant of a telling expression. Ensure intense eye contact in portraits for a sense of intimacy. Use a long shutter speed to depict the fluid motion of the batter connecting with the ball. Anticipate and record the peak of action at a high jump competition. Produce an impression of speed by panning with a race car, streaking the background.

Study photos and even paintings to learn how color affects the mood or message conveyed. Muted colors are more calming and less distracting, allowing the viewer to focus on the photos content. Vibrant color are more eye-catching and can instantly increase the impact of a photo. In a monochromatic scene, find a dash of color to act as a key element or an accent. Just be aware that the viewer's eye will be drawn to the spot of color; it should relate to the subject, not compete with it.

Placing the subject on the diagonal is a common compositional technique which adds a dynamic element to a photograph.

# Conclusion

Instead of taking the same pictures over and over again, try expressing creativity through a variety of techniques. Break free of the constraints imposed by rules, but do so with a specific purpose. Some of the resulting photos will be failures but others will stand out from the more conventional pictures hanging on your wall.

The assessment of any image as good or bad, dynamic or boring, is a highly subjective judgment. However, unless you shoot strictly for yourself, keep the interests of subsequent viewers in mind. Study the photographs of those you most admire. Without resorting to imitation, develop strategies for effective communication. These tips should help you start getting the most from your Nikon N70/F70, and maximize the potential of the exceptional AF Nikkor lenses.